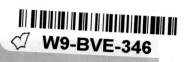

Gaston-Albert Lavrillier.

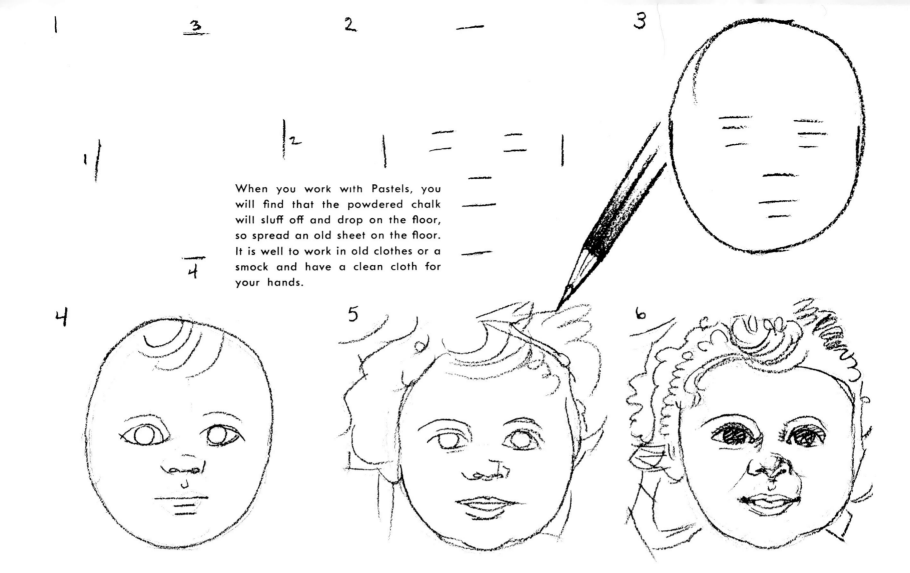

When you work with Pastels, you will find that the powdered chalk will sluff off and drop on the floor, so spread an old sheet on the floor. It is well to work in old clothes or a smock and have a clean cloth for your hands.

OF all the pastel papers and boards I still prefer charcoal papers and illustration boards (rough or cold-pressed and smooth or hot pressed). You can tint illustration board with water colors or use solid casein colors as shown in several pictures throughout this book, you can erase and it is a great deal more flexible and not so hard on your fingers, if you us them to blend as most artists do instead of the paper or leather stumps. Try all papers and mediums including the new Oil Pastels shown on pages 15 and 20.

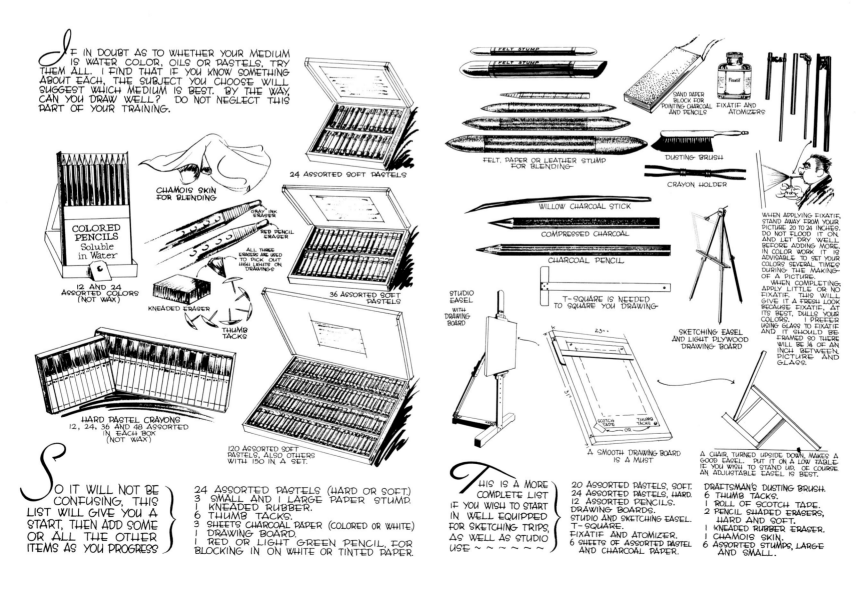

IF IN DOUBT AS TO WHETHER YOUR MEDIUM IS WATER COLOR, OILS OR PASTELS, TRY THEM ALL. I FIND THAT IF YOU KNOW SOMETHING ABOUT EACH, THE SUBJECT YOU CHOOSE WILL SUGGEST WHICH MEDIUM IS BEST. BY THE WAY, CAN YOU DRAW WELL? DO NOT NEGLECT THIS PART OF YOUR TRAINING.

CHAMOIS SKIN FOR BLENDING

GRAY INK ERASER

RED PENCIL ERASER

ALL THREE ERASERS ARE USED TO PICK OUT HIGH LIGHTS ON DRAWINGS.

COLORED PENCILS Soluble in Water

12 AND 24 ASSORTED COLORS (NOT WAX)

KNEADED ERASER

THUMB TACKS

24 ASSORTED SOFT PASTELS

36 ASSORTED SOFT PASTELS

HARD PASTEL CRAYONS 12, 24, 36 AND 48 ASSORTED IN EACH BOX (NOT WAX)

120 ASSORTED SOFT PASTELS, ALSO OTHERS WITH 150 IN A SET.

FELT STUMP

FELT, PAPER OR LEATHER STUMP FOR BLENDING

SAND PAPER BLOCK FOR POINTING CHARCOAL AND PENCILS

FIXATIF AND ATOMIZERS

DUSTING BRUSH

CRAYON HOLDER

WILLOW CHARCOAL STICK

COMPRESSED CHARCOAL

CHARCOAL PENCIL

STUDIO EASEL WITH DRAWING BOARD

T-SQUARE IS NEEDED TO SQUARE YOU DRAWING

SKETCHING EASEL AND LIGHT PLYWOOD DRAWING BOARD

A SMOOTH DRAWING BOARD IS A MUST

WHEN APPLYING FIXATIF, STAND AWAY FROM YOUR PICTURE 20 TO 24 INCHES AND LET DRY. DO NOT FLOOD IT ON, AND LET DRY WELL BEFORE ADDING MORE. IN COLOR WORK IT IS ADVISABLE TO SET YOUR COLORS SEVERAL TIMES DURING THE MAKING OF A PICTURE.

WHEN COMPLETING, APPLY LITTLE OR NO FIXATIF, THIS WILL GIVE IT A FRESH LOOK BECAUSE FIXATIF, AT ITS BEST, DULLS YOUR COLORS. I PREFER USING GLASS TO FIXATIF AND IT SHOULD BE FRAMED SO THERE WILL BE ⅛ OF AN INCH BETWEEN PICTURE AND GLASS.

A CHAIR, TURNED UPSIDE DOWN, MAKES A GOOD EASEL. PUT IT ON A LOW TABLE. IF YOU WISH TO STAND UP, OF COURSE AN ADJUSTABLE EASEL IS BEST.

SO IT WILL NOT BE CONFUSING, THIS LIST WILL GIVE YOU A START, THEN ADD SOME OR ALL THE OTHER ITEMS AS YOU PROGRESS

24 ASSORTED PASTELS (HARD OR SOFT.)
3 SMALL AND 1 LARGE PAPER STUMP.
1 KNEADED RUBBER.
6 THUMB TACKS.
3 SHEETS CHARCOAL PAPER (COLORED OR WHITE)
1 DRAWING BOARD.
1 RED OR LIGHT GREEN PENCIL, FOR BLOCKING IN ON WHITE OR TINTED PAPER.

THIS IS A MORE COMPLETE LIST IF YOU WISH TO START IN WELL EQUIPPED FOR SKETCHING TRIPS, AS WELL AS STUDIO USE ~~~~~

20 ASSORTED PASTELS, SOFT.
24 ASSORTED PASTELS, HARD.
12 ASSORTED PENCILS.
DRAWING BOARDS.
STUDIO AND SKETCHING EASEL.
T-SQUARE.
FIXATIF AND ATOMIZER.
6 SHEETS OF ASSORTED PASTEL AND CHARCOAL PAPER.

DRAFTSMAN'S DUSTING BRUSH.
6 THUMB TACKS.
1 ROLL OF SCOTCH TAPE.
2 PENCIL SHAPED ERASERS, HARD AND SOFT.
1 KNEADED RUBBER ERASER.
1 CHAMOIS SKIN.
6 ASSORTED STUMPS, LARGE AND SMALL.

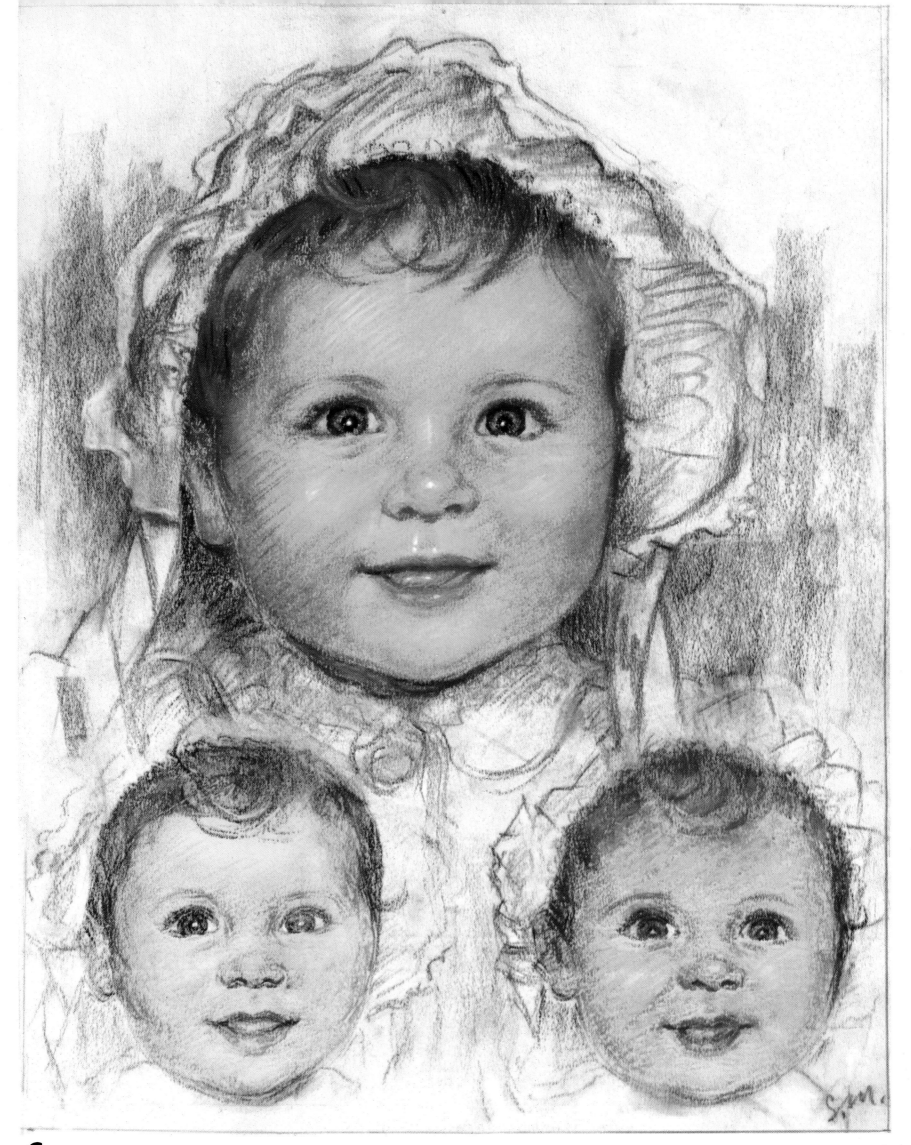

CHILDREN are not the easiest subjects so if your first starts are not good, try again. Stella Mackie has been very successful with making children's portraits as well as older people as you will find on pages 9 and 11, and you will find more in her two books "Portraits and How to Do Them" and "Portraits in Oils". Why, sure you can draw from Oils and use pastels or watercolors. The step drawings are just the same, and you will be surprised at the different effects you will get.

*P*astels and pencils are generally our first venture in color and is a very direct way of finding out about colors. When using pastels one does not depend so much upon the blending of colors by mixing, as in water colors and oils, but you choose the color from your box of pastels and apply it directly to your paper. This is the reason for having so many colors and tints.

COLORED PENCILS

A pocket size, folding, single easel box; holds one each of the 12 colors listed below.

Purple	Orange	Red
Lt. Blue	Brown	Yellow
Lt. Green	Heliotrope	Dark Green
Black	Dark Blue	Carmine

HARD PASTELS

Square, 3⅝ Inches Long
Round, 6 Inches Long

Burnt Sienna	Prussian Blue	Deep Cadmium
Sandal Wood	Scarlet	Yellow
Peacock Blue	Hooker's Green	Viridian Green
Carmine	Black	Indian Red
Deep Chrome	Raw Sienna	Ultramarine Blue
Yellow	Red Violet	Pale Vermilion
Sap Green	Light Blue	Prussian Green
White	Carmine Madder	Deep Ultramarine
Deep Orange	Slate Grey	Flesh Pink
Terra Cotta	Light Ochre	Ivory
Tuscan Red	Rose Pink	Vandyke Brown
Lemon Yellow	Light Naples	Indigo
Veronese Green	Yellow	Madder Pink
Light Grey	Olive Green	Pistachio Green
Orange	Cocoa Brown	Sepia
Burnt Umber	Hyacinth Violet	Salmon Pink
Violet	Saturn Red	Bottle Green

SOFT PASTELS

Most of the colors have four to six tints, so this list adds up to something over 150 colors and tints.

White		**REDS**	**Tints**	**GREENS**	**Tints**
Black		Crimson madder	4	Blue green . .	6
Warm White		Flesh ochre .	3	Chrome green .	4
		Geranium . .	5	Emerald green .	5
GRAYS		Light red .	6	Terre Verte .	3
Black gray		Indian red . .	6	Olive green .	5
Blue gray (cold gray)		Scarlet . .	5	Deep green .	4
Br. gray (warm gray)		Vermilion .	4	**BLUES**	
		Cadmium red .	4	Cerulean blue .	4
BROWNS				Cobalt blue . .	5
	Tints	**YELLOW**		Prussian blue .	3
Brown red .	6	Cadmium yellow	4	Ultramarine .	4
Burnt sienna . .	4	Chrome yellow .	6		
Burnt Umber . .	4	Chrome orange .	5	**VIOLETS**	
Raw Sienna . .	5	Lemon yellow .	4	Blue violet . .	5
Raw Umber . .	4	Naples yellow .	5	Red violet .	4
Van Dyke Brown	3	Yellow ochre .	4	Mauve . .	4
Deep brown .	4	Golden ochre .	5	Deep violet .	4
				Deep purple .	5

For list of water colors see direction sheet of "Water Color Painting" by Walter T. Foster, listed in back of this book.

Pencil strokes on 9 different papers.	Hard pastels on 9 different papers.	Soft pastels on 9 different papers.	Water colors used for base on 5 papers.
Colored pencils come in boxes of 12 to 64 different colors.	Hard pastels come in sets of 12 to 48 different colors.	Soft pastels come in sets of 12 to 150 different colors.	This is a green water color wash on cold pressed illustration board. Carmine wash. Lower right hand corner.
These colors are blended with paper stump on hot pressed illustration board.	Red, green and yellow were worked over each other; no rubbing.	Yellow was applied, leaving white spaces, then red was worked over yellow. No rubbing.	A brown water color wash was used, let dry, then green, yellow, white and rose strokes were made with hard pastels.
Blue, red and purple strokes on a very smooth Bristol board; no rubbing.	Rose, green, blue and red strokes on a very smooth Bristol board.	Yellow soft pastel was used on Bristol board, leaving white paper, then using red and gray green short strokes.	A rose water color wash with yellow, green and blue of soft pastel; no rubbing.
Notice the contrast between these two papers, using same pencils.	The contrast in strokes on these two papers will give you some idea what can be done.	Soft pastels work very well on this rough water color paper. You can blend it with paper stump.	This is a red water color wash over the white paper, with strokes of white, yellow, green and blue.
As you can see, the velvet pastel paper does not take pencil.	Velvet pastel paper works just fair with hard pastels.	Velvet pastel paper is fine for soft pastels.	Velvet pastel paper will not take water colors. Red, yellow and blue blended with stump.
Sanded surface good for pencil.	Sanded surface works fine with hard pastels.	Sanded surface good for soft pastels. Hard on fingers. Blend with paper stump.	Colors have more contrast on sand coated paper than on the velvet above.
Colored pencils work well on this white charcoal paper.	Hard pastels work well on white charcoal paper.	Soft pastels are easily blended on white charcoal paper.	This is a green water color tint on white charcoal paper, with pastel strokes of blue, yellow and carmine over wash.
This brown charcoal paper works best with light and dark colors for contrast.	Use this brown charcoal paper for your middle tones, highlight your drawings with white.	This brown charcoal paper gives a very nice effect where it shows through the other colors.	Yellow pastels on brown charcoal paper, blended with stump. Try with different colors.
The blue charcoal paper is limited but at times very effective.	With this blue charcoal paper you can work in light pastel colors, as well as brilliant reds and yellows.	Blue charcoal paper shows through the spots and around the edges, works well with soft pastels.	Yellow pastels over blue charcoal paper. When blended it mixes with blue paper and gives green.

SEE COLOR EXAMPLES ON PAGE 5.

*H*ave you read through the list of colors? Confusing, isn't it? You may say "well this is way beyond me, I couldn't even memorize the names!" Let me assure you that all of these colors are not necessary to start with, and I would suggest starting with a box of 12 assorted pencils or 12 or 24 hard pastels, or a set of 24 or 48 soft pastels, whichever you wish to try first. Now, if you wish to be a real plunger, get all three sets. They will not cost much and the fun of trying them altogether will repay you many times. This will give you an assortment with which any artist could make a masterpiece. A good, smooth drawing board, to thumb tack or tape your drawing to, is very essential. A chair, desk, stool or anything to lean it against, will do for an easel. The main thing is to make the start, and you owe this to yourself, if you have ever had the desire to paint. This idea of being born to it—or getting your talents from your great auntie, is just pure hokum. Do not limit yourself

by thinking that you can't. No one knows until you try and when I say *try* I do not mean just buying this book and materials and quitting. Try everything you like in this book, work from still life, go to art school, (at night if necessary), meet people with the same interests. Every city and town should have a get-together of men and women who are interested in drawing and painting, and many do. I had the pleasure of visiting a Business Men's Art Club the other night. Some of our most representative business men, movie actors and men from every walk of life were there. They now have an Art School with paid instructors, located in a beautiful old home they own. All this is paid for by modest dues. It was started in an artist's studio several years ago. As in amateur sports, you are no longer a member once you start selling your work.

Why not start one, or look up a club or art school and join? You are missing much if you don't.

The effect you obtain with pastels depends largely upon the surface of the papers you choose. In the color reproductions below, you will find nine different papers, with effects you will get using colored pencils, hard pastels and soft pastels.

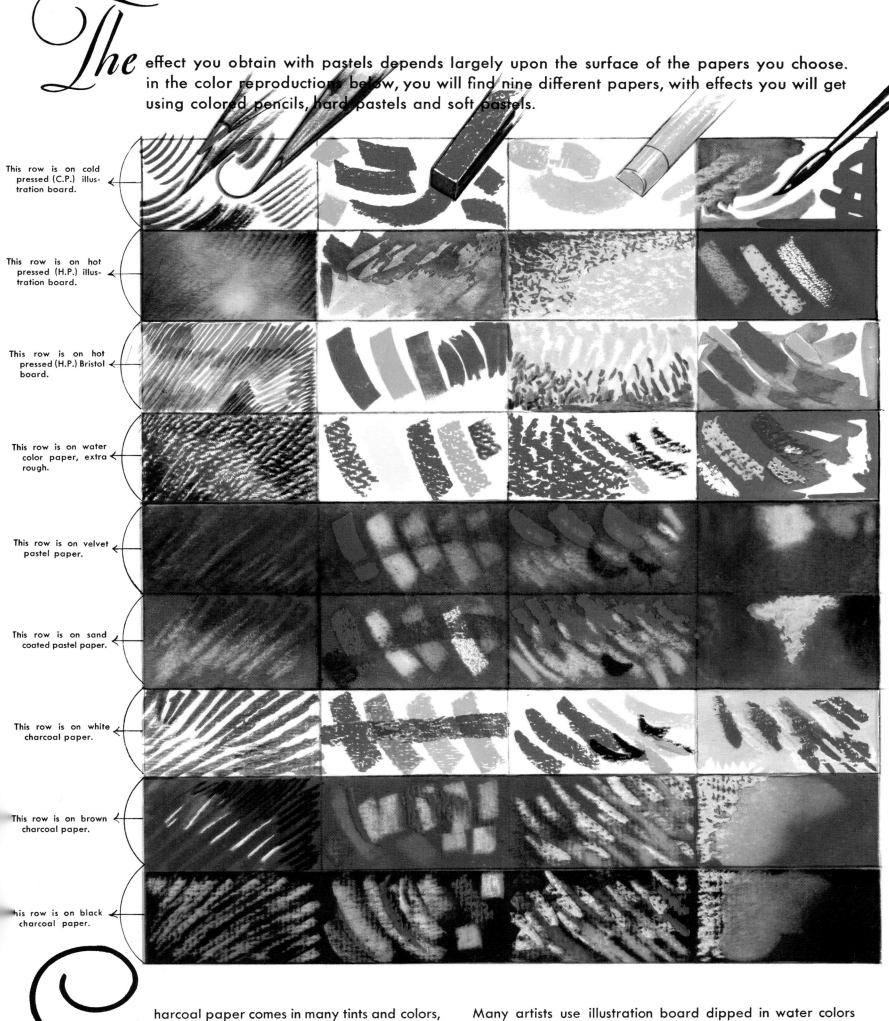

This row is on cold pressed (C.P.) illustration board.

This row is on hot pressed (H.P.) illustration board.

This row is on hot pressed (H.P.) Bristol board.

This row is on water color paper, extra rough.

This row is on velvet pastel paper.

This row is on sand coated pastel paper.

This row is on white charcoal paper.

This row is on brown charcoal paper.

This row is on black charcoal paper.

*C*harcoal paper comes in many tints and colors, is inexpensive and fine for practice as well as finish work. Then there are papers and boards made just for pastels; the velvet finish, fibre finish and sanded finish are the ones most used.

Many artists use illustration board dipped in water colors or dyes, or you can brush it on, (wet surface of paper first in clear water, by dipping or with brush, before applying colors.) In this way you can get any tint you wish and it will be smooth. Yours for success and fun.

Walter Foster

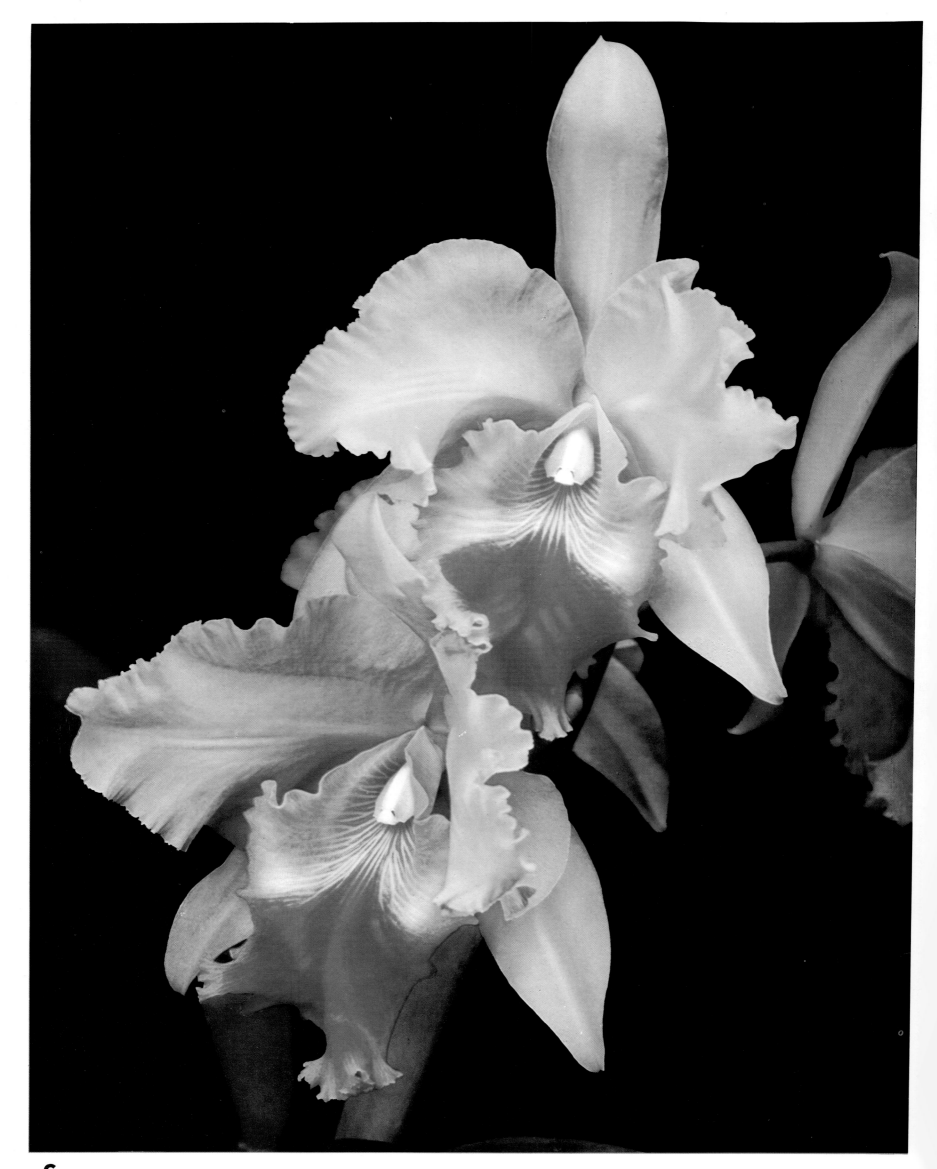

SO you can see the pastel drawing of the orchid, I have used just the one so it can be made large, but you put in as many as you wish. When working from photos do not try to put in every little detail in your drawing, but simplify and suggest, giving it a special interest. You will find this and many other flower prints in "How to Draw and Paint Flowers". Try these orchids in oils or watercolors, you will find the results most interesting. The step-drawings are the same.

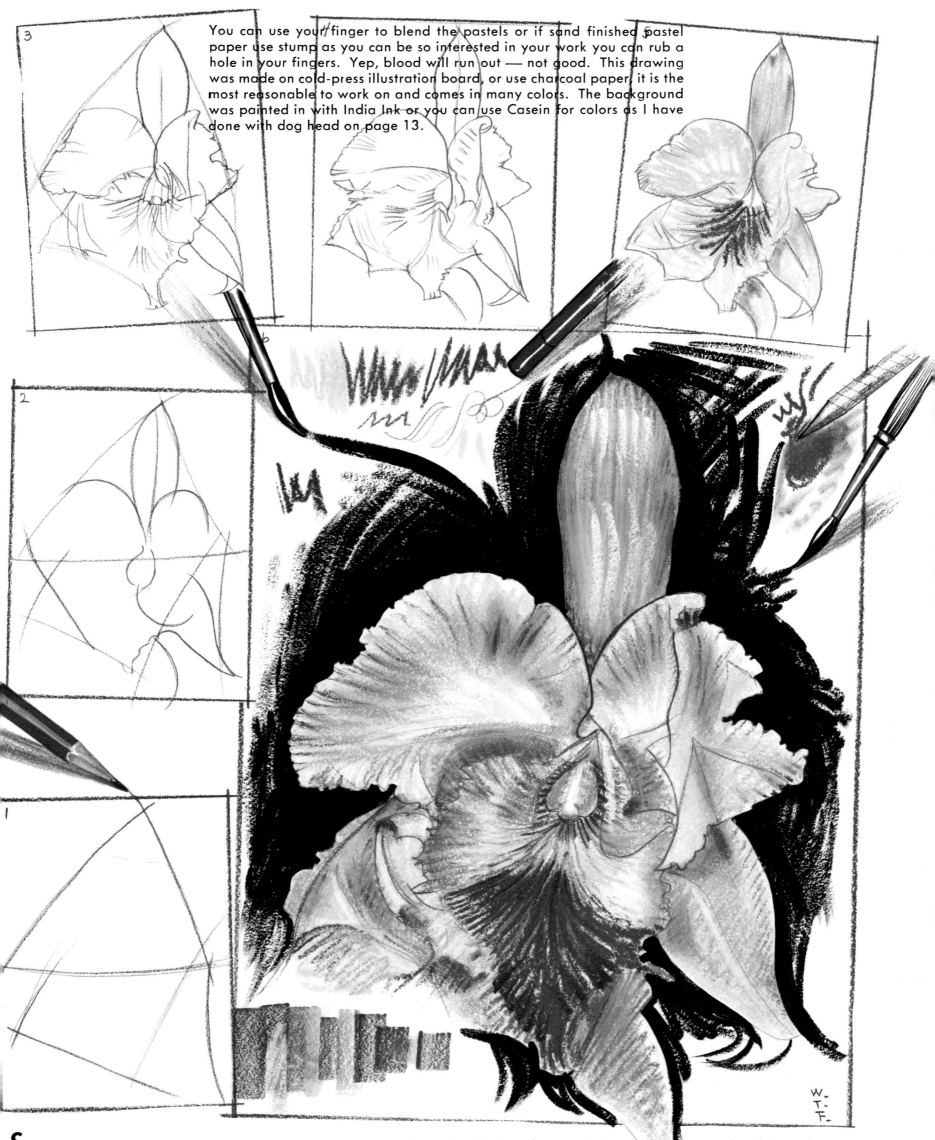

You can use your finger to blend the pastels or if sand finished pastel paper use stump as you can be so interested in your work you can rub a hole in your fingers. Yep, blood will run out — not good. This drawing was made on cold-press illustration board, or use charcoal paper, it is the most reasonable to work on and comes in many colors. The background was painted in with India Ink or you can use Casein for colors as I have done with dog head on page 13.

STUDY step one, it has lots more meaning than just 6 or 7 lines, it is the foundation of all good drawing. To be able to place your drawing in a given space is one of the greatest helps you can possess. If I can just get this one thing over to you, and you can get into the habit of doing this on every drawing you make, so it becomes part of you, I will feel well repaid for doing this book along with all the others, so please **do** try. Thanks. O, yes, when working with pastels put the pastel sticks back in their same places after you use them, or you will find yourself in a mess, pastels all mixed up.

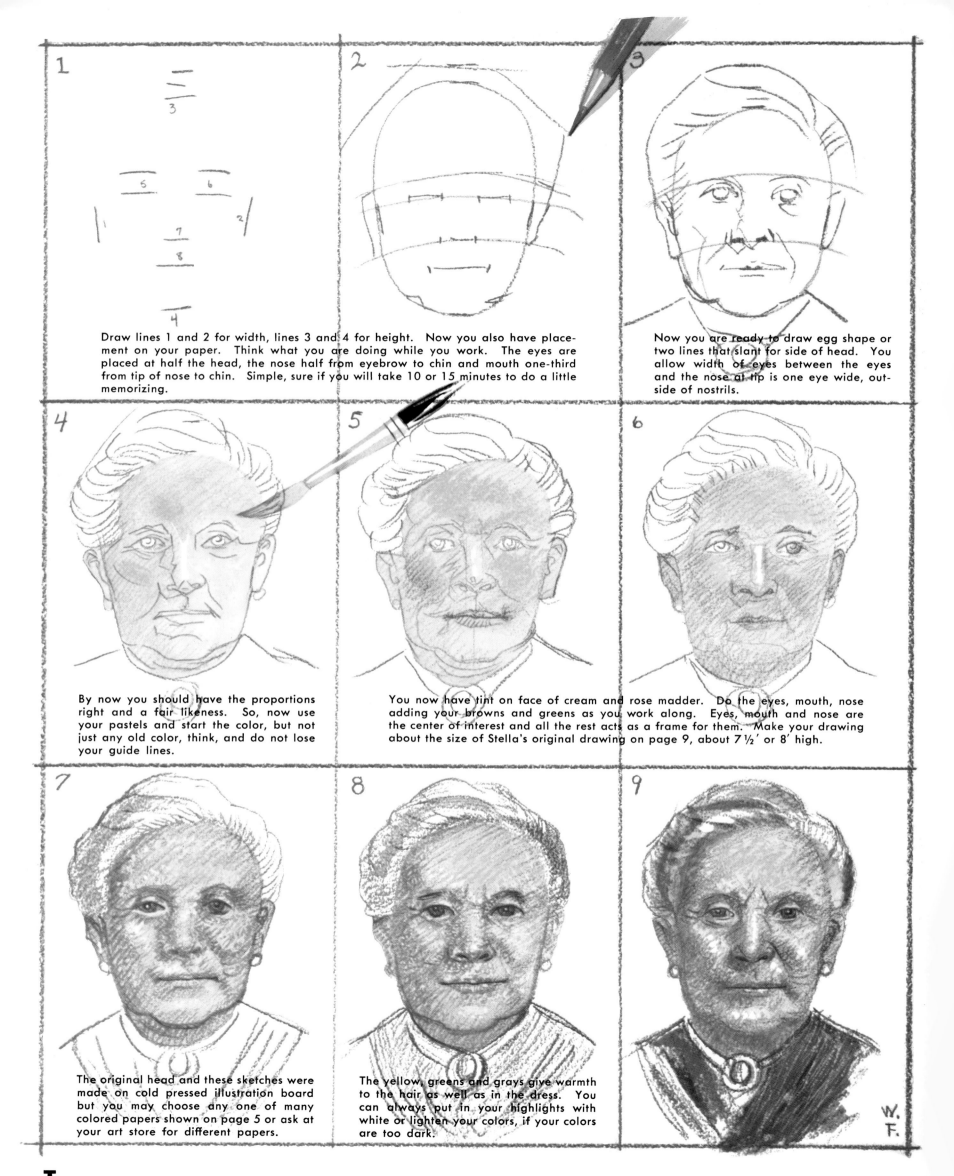

1

Draw lines 1 and 2 for width, lines 3 and 4 for height. Now you also have placement on your paper. Think what you are doing while you work. The eyes are placed at half the head, the nose half from eyebrow to chin and mouth one-third from tip of nose to chin. Simple, sure if you will take 10 or 15 minutes to do a little memorizing.

2

3

Now you are ready to draw egg shape or two lines that slant for side of head. You allow width of eyes between the eyes and the nose at tip is one eye wide, outside of nostrils.

4

By now you should have the proportions right and a fair likeness. So, now use your pastels and start the color, but not just any old color, think, and do not lose your guide lines.

5

6

You now have tint on face of cream and rose madder. Do the eyes, mouth, nose adding your browns and greens as you work along. Eyes, mouth and nose are the center of interest and all the rest acts as a frame for them. Make your drawing about the size of Stella's original drawing on page 9, about 7½' or 8' high.

7

The original head and these sketches were made on cold pressed illustration board but you may choose any one of many colored papers shown on page 5 or ask at your art store for different papers.

8

The yellow, greens and grays give warmth to the hair as well as in the dress. You can always put in your highlights with white or lighten your colors, if your colors are too dark.

9

W. F.

THEY say confession is good for the soul and here is mine. I had one heck of a time getting back to anywhere near the likeness of Stella's lady, but that is the way it goes, working from some one elses drawing. I will have Stella Mackie do the new breakdowns or step-drawings when she does her book over. No wonder she only wanted to make 4 step-drawings instead of 6 or 9 as I have done. Too much work. "Why Stella! Shame on you!!"

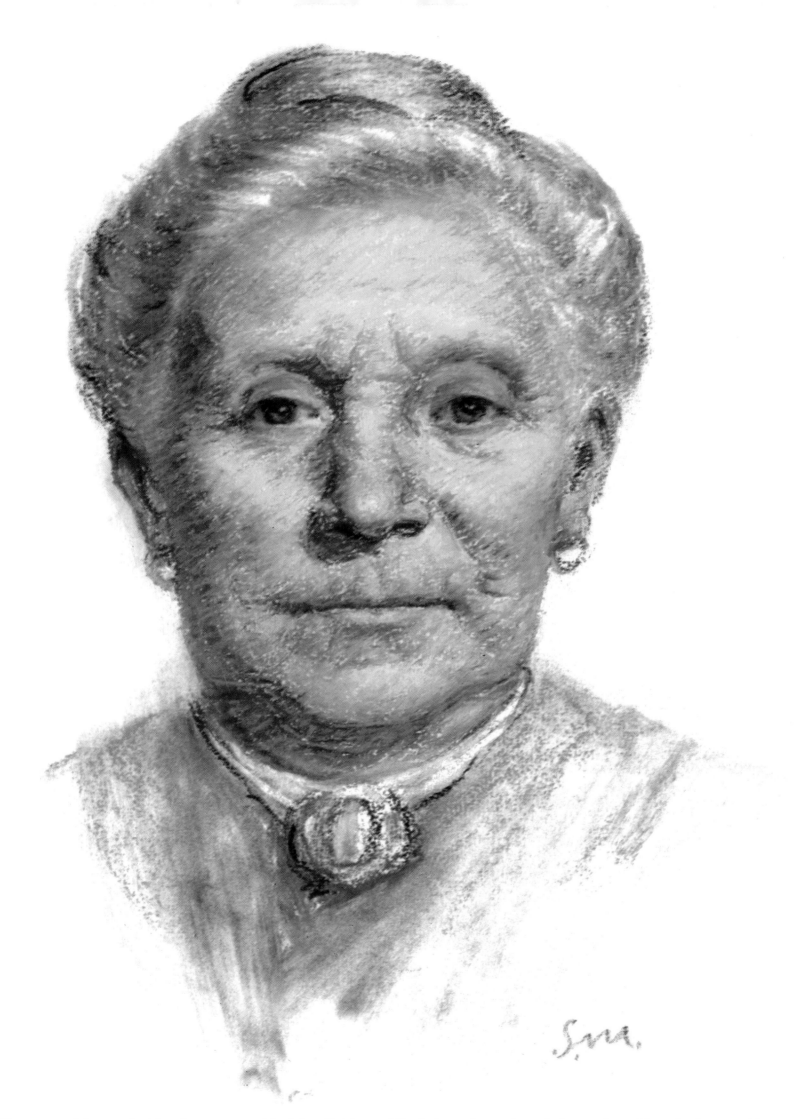

If you are doing a sketch where your subject has light or white hair and you do not choose to put in a background to show it to advantage, take your water color board, make a wash of aniline dye of the color you desire (a light umber or buff is good), then work in your portrait, using the Cross Hatching method—splendid for elderly people. Several colors can be employed, but make the second strokes cross the first at an angle. If you find you need to rub (with your thumb or little finger) the hair, for instance, be very careful as if overdone it can spoil the whole effect. Use as few colors as possible—light red, yellow ochre, greys and greens. Some artists prefer buying their pastels separately, but there are boxes of pastels on the market which are sold for portraiture alone.

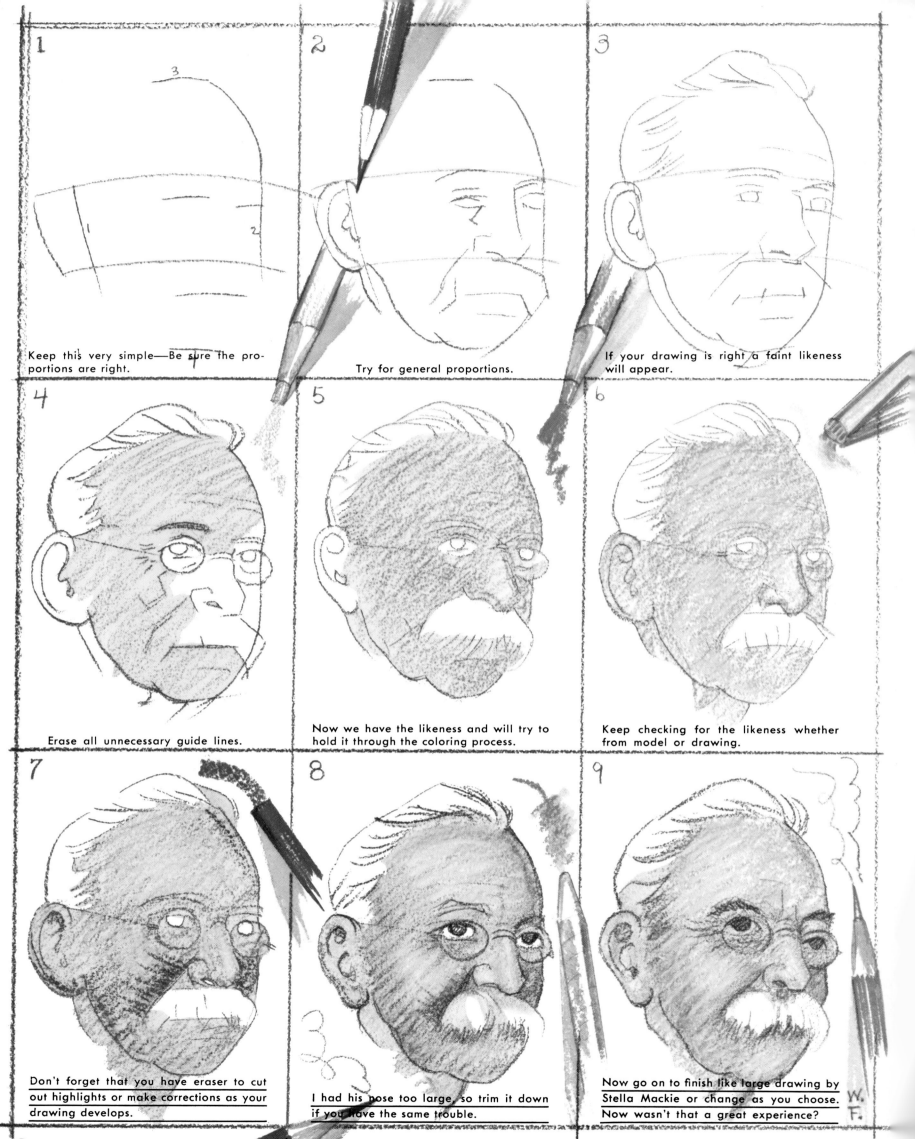

1 Keep this very simple—Be sure the proportions are right.

2 Try for general proportions.

3 If your drawing is right a faint likeness will appear.

4 Erase all unnecessary guide lines.

5 Now we have the likeness and will try to hold it through the coloring process.

6 Keep checking for the likeness whether from model or drawing.

7 Don't forget that you have eraser to cut out highlights or make corrections as your drawing develops.

8 I had his nose too large, so trim it down if you have the same trouble.

9 Now go on to finish like large drawing by Stella Mackie or change as you choose. Now wasn't that a great experience? W. F.

ONE of the greatest faults of all beginners is starting with the subjects that are away beyond their ability. It not only discourages one but is so impractical. It is like singing Grand Opera without having taken voice lessons. Shall we start on <u>do re me</u> in drawing? Fine. In just 10 days I fly to Mexico City, then to Lima, Peru, where I will meet my friend Clarence Hall, Senior Editor of The Readers Digest. From there a Missionary plane will fly us over the Andes into the jungles of Brazil, where Clarence will write an article about some young linguist, when we return we fly to Bogota, Caracas, San Juan and we will stop off at Haiti where we will do a bit of probing into voodoo.

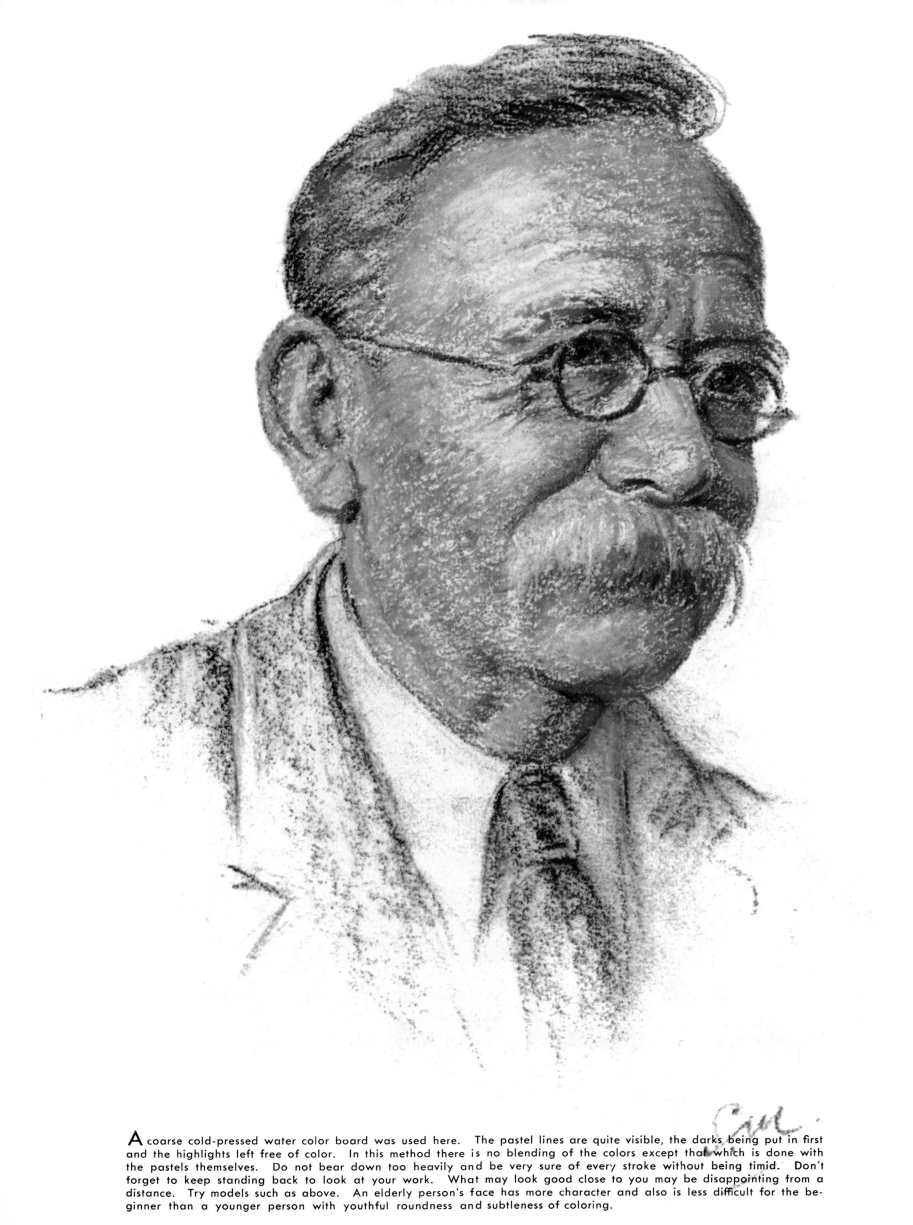

A coarse cold-pressed water color board was used here. The pastel lines are quite visible, the darks being put in first and the highlights left free of color. In this method there is no blending of the colors except that which is done with the pastels themselves. Do not bear down too heavily and be very sure of every stroke without being timid. Don't forget to keep standing back to look at your work. What may look good close to you may be disappointing from a distance. Try models such as above. An elderly person's face has more character and also is less difficult for the beginner than a younger person with youthful roundness and subtleness of coloring.

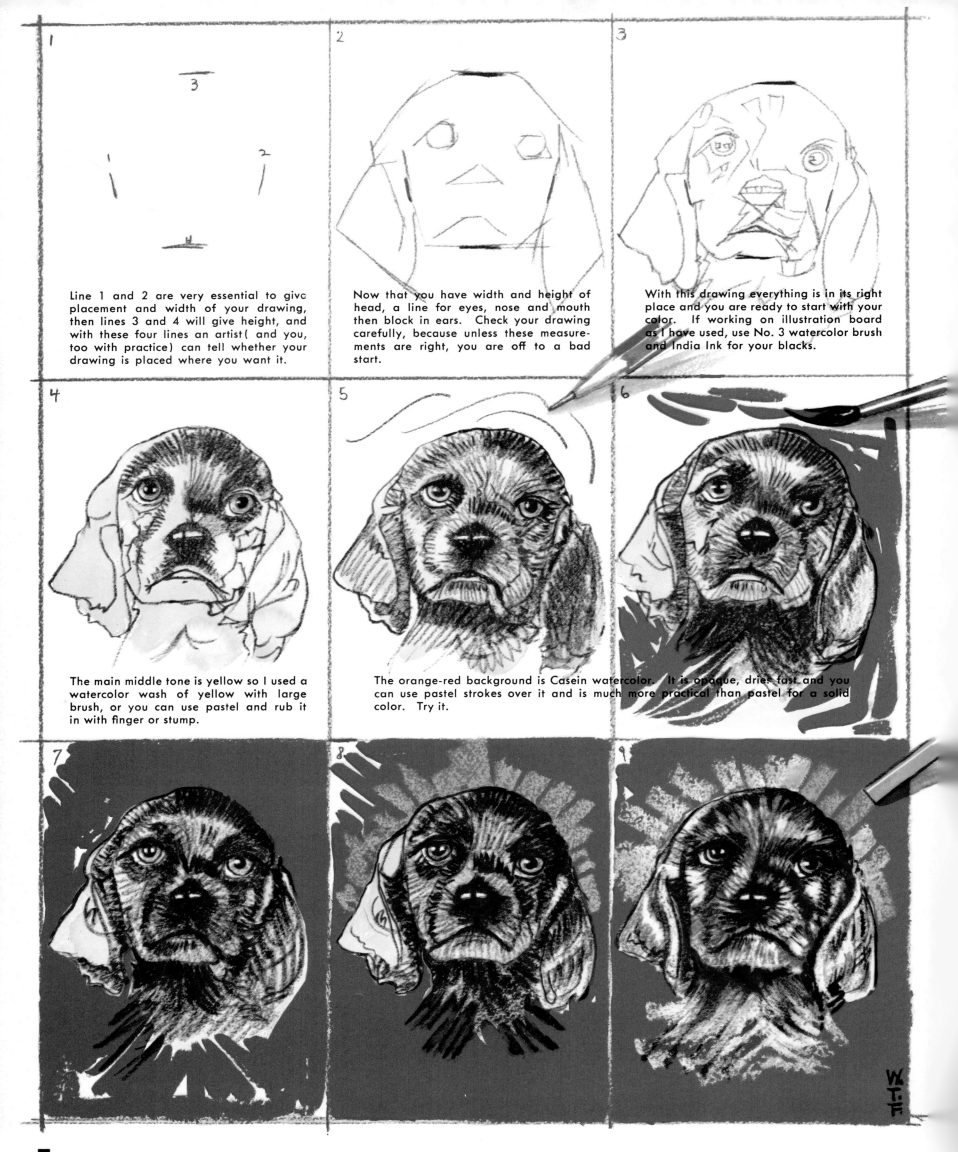

1. Line 1 and 2 are very essential to give placement and width of your drawing, then lines 3 and 4 will give height, and with these four lines an artist (and you, too with practice) can tell whether your drawing is placed where you want it.

2. Now that you have width and height of head, a line for eyes, nose and mouth then block in ears. Check your drawing carefully, because unless these measurements are right, you are off to a bad start.

3. With this drawing everything is in its right place and you are ready to start with your color. If working on illustration board as I have used, use No. 3 watercolor brush and India Ink for your blacks.

4. The main middle tone is yellow so I used a watercolor wash of yellow with large brush, or you can use pastel and rub it in with finger or stump.

5. The orange-red background is Casein watercolor. It is opaque, dries fast and you can use pastel strokes over it and is much more practical than pastel for a solid color. Try it.

THE head is well-rounded out and the expression you want (I hope). You will note that these step-drawings vary from step to step, as each is a separate drawing and while I have held fairly close, it is quite impossible to duplicate each stroke or expression, then it would lose its freedom as well as the real fun of doing them.

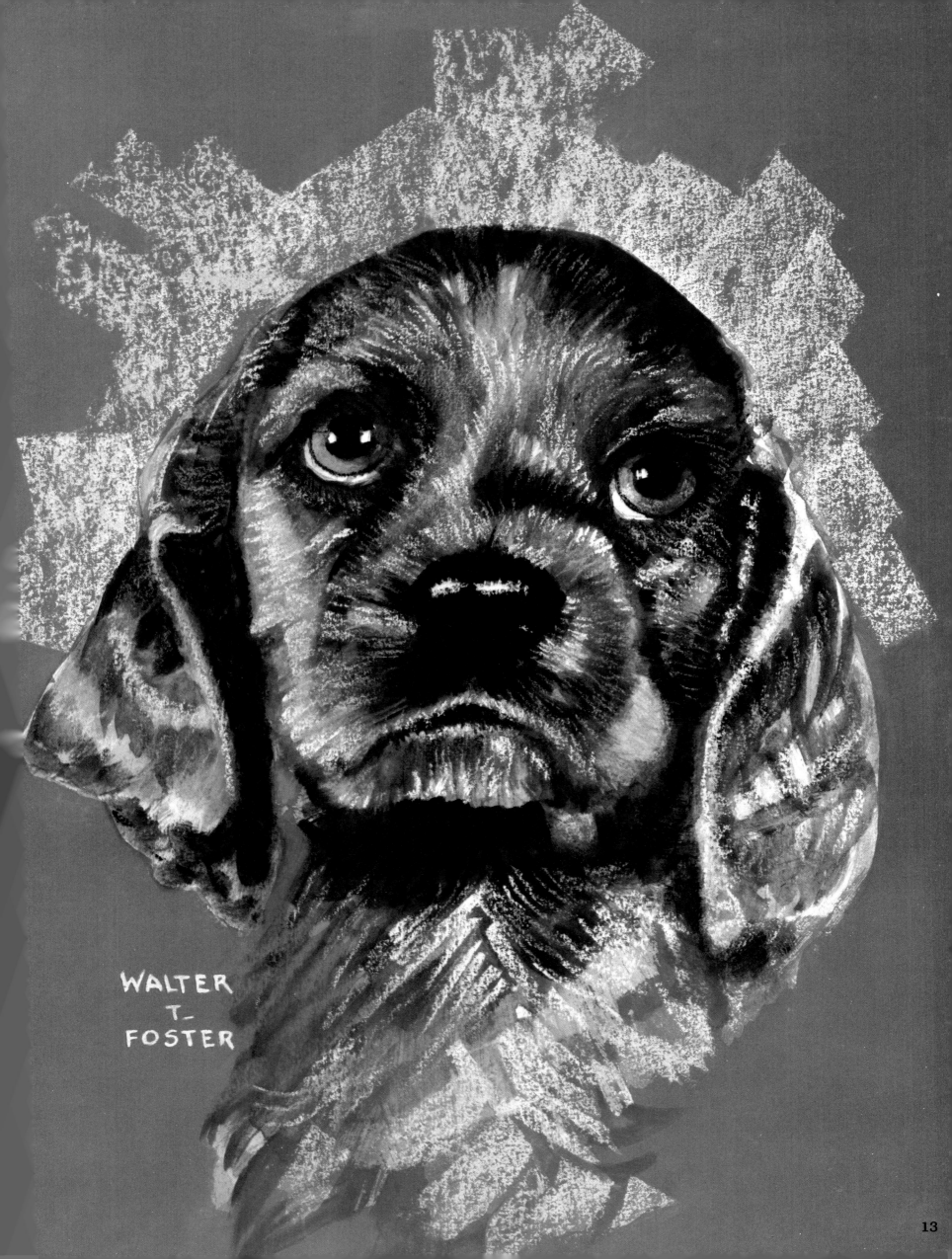

WALTER
T.
FOSTER

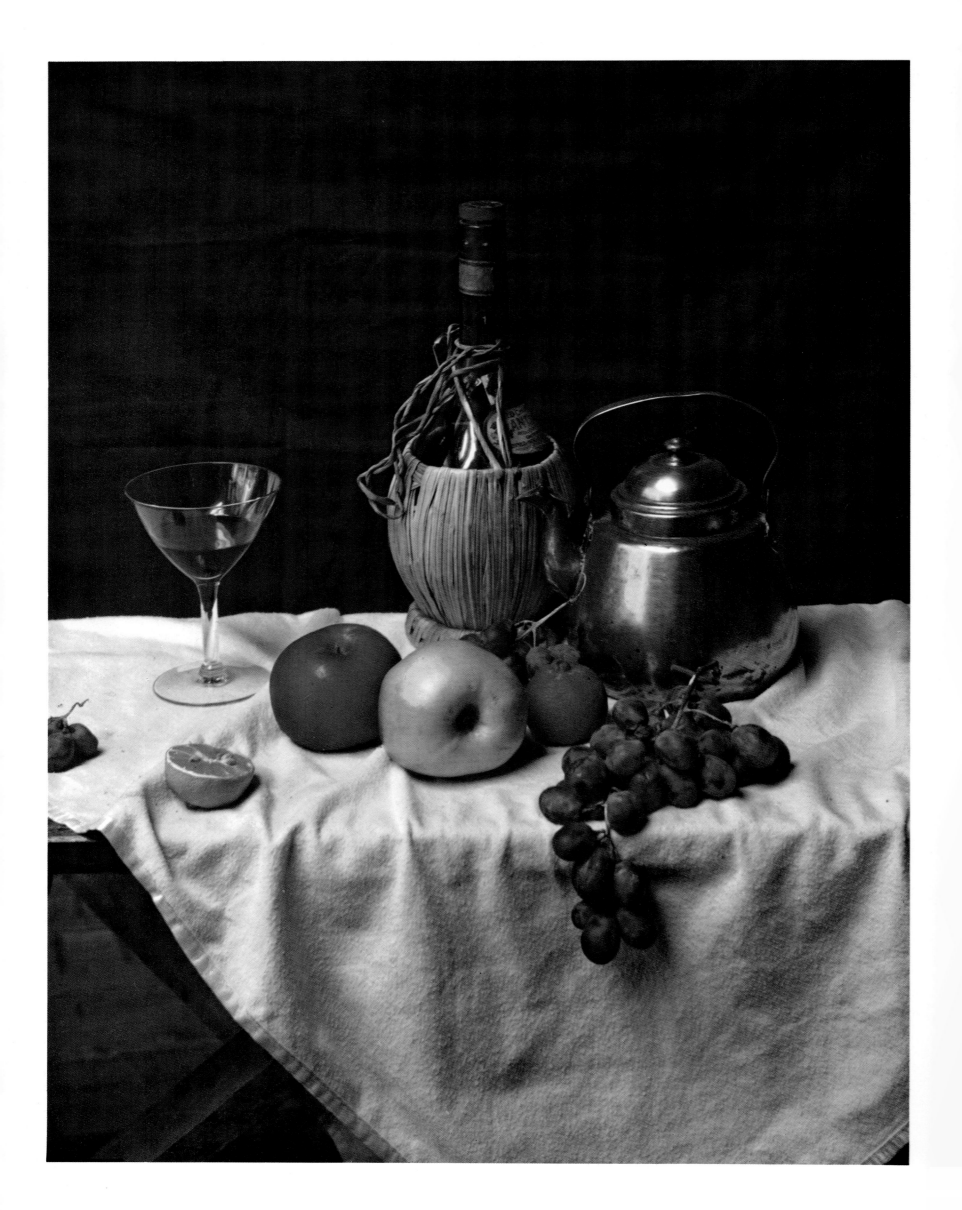

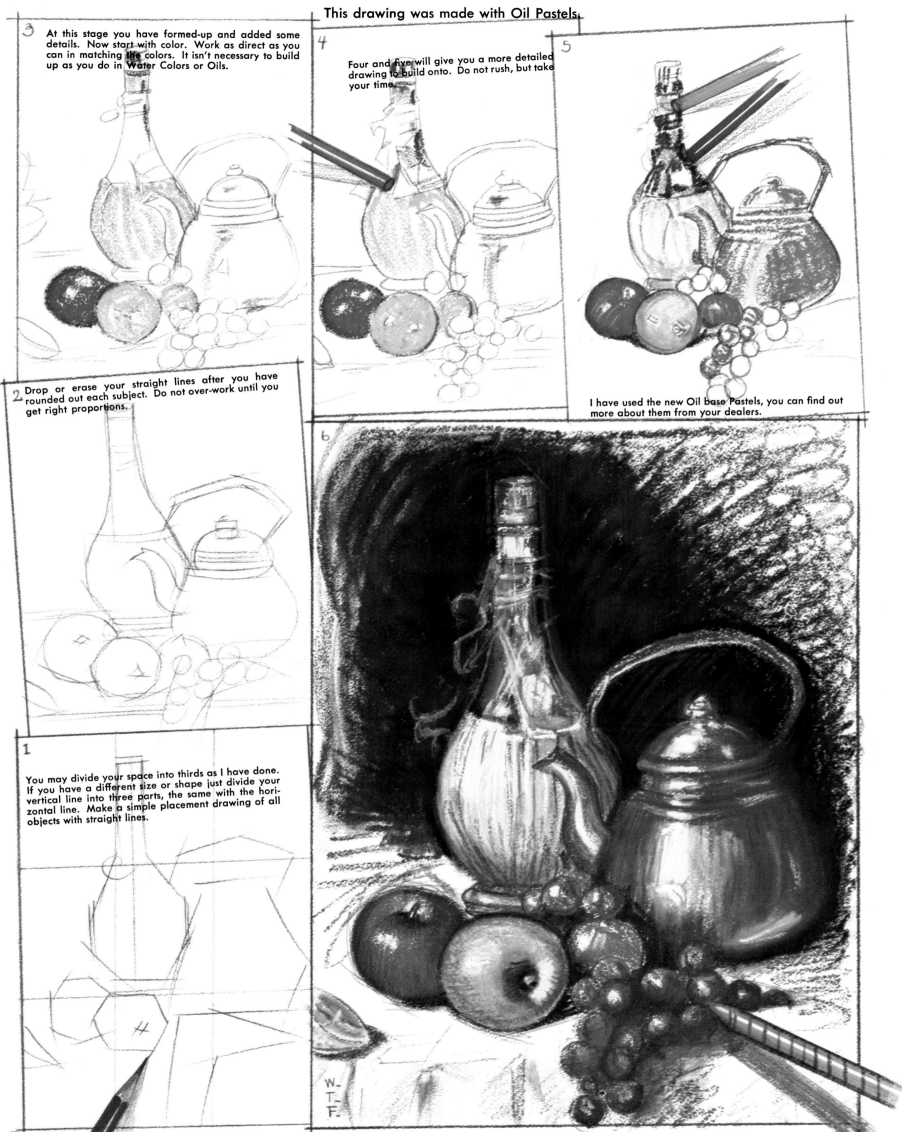

3 At this stage you have formed-up and added some details. Now start with color. Work as direct as you can in matching the colors. It isn't necessary to build up as you do in Water Colors or Oils.

4 Four and five will give you a more detailed drawing to build onto. Do not rush, but take your time.

5 I have used the new Oil base Pastels, you can find out more about them from your dealers.

2 Drop or erase your straight lines after you have rounded out each subject. Do not over-work until you get right proportions.

1 You may divide your space into thirds as I have done. If you have a different size or shape just divide your vertical line into three parts, the same with the horizontal line. Make a simple placement drawing of all objects with straight lines.

6

W.
T.
F.

THE step-drawings speak for themselves if you will only follow each closely and do not get ahead of yourself as so many do. I know you want to see color on your drawing but that is no good unless your drawing is right. Set up your own still life and work from it. Better still draw only one apple, pear or banana at a time. Often good talent is discouraged by trying subjects that are too difficult. Just think of tossing one ball in the air, then two and then juggling three. Well, the same with drawing or painting, the more balls in the air at once, the more difficult, so stick to two or three objects in your painting, whether it be apples, bottles, or tea kettle. Have fun.

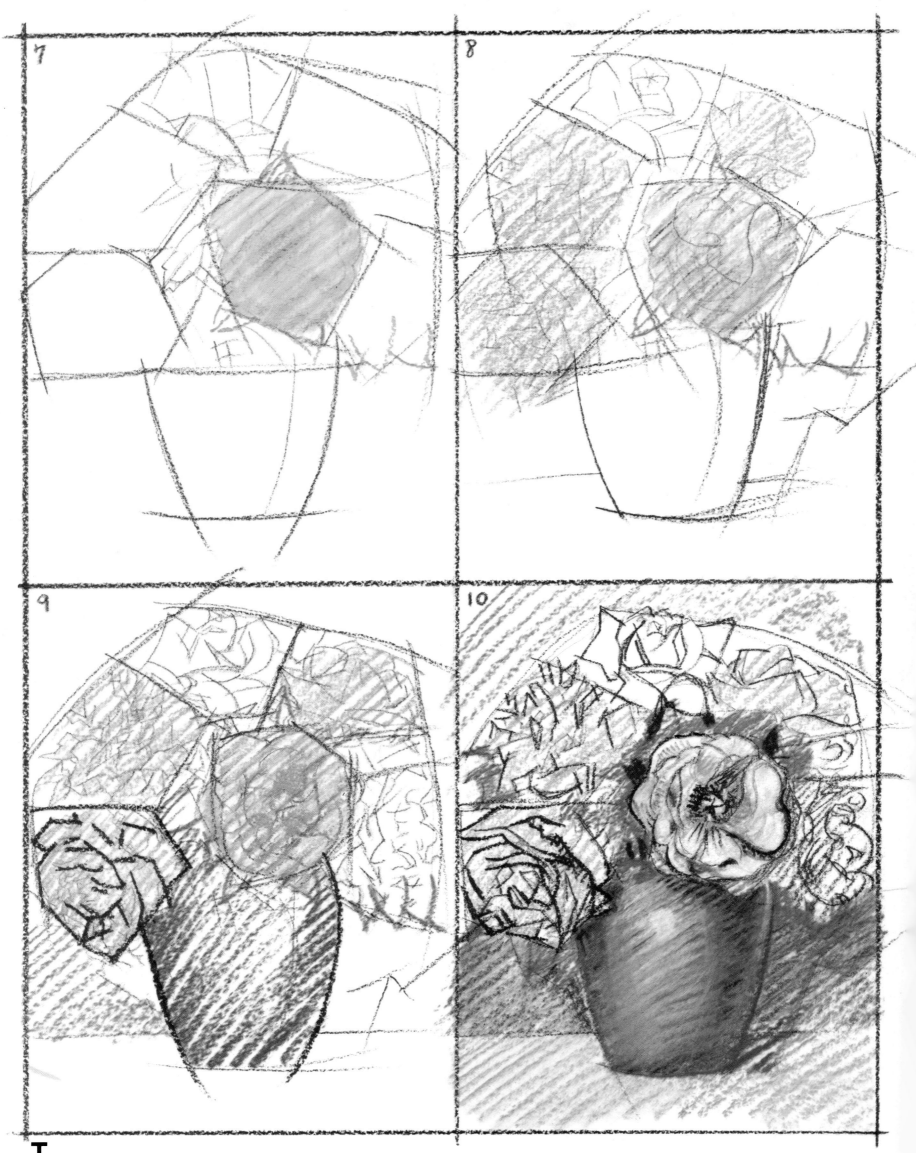

THE tendency when working in pastels, oils or casein is to work over your outlines or guide lines so they are obliterated and this is the advantage of good blocking-in as each object (flower in this case) is separated and you know where each belongs, so you may concentrate on each flower or leaf, until it is well along, and when each is well-established place your drawing across the room so you can best see the changes you wish to make — by adding darks here, lights there, until you have what you are striving for. This is not an easy subject, so take your time.

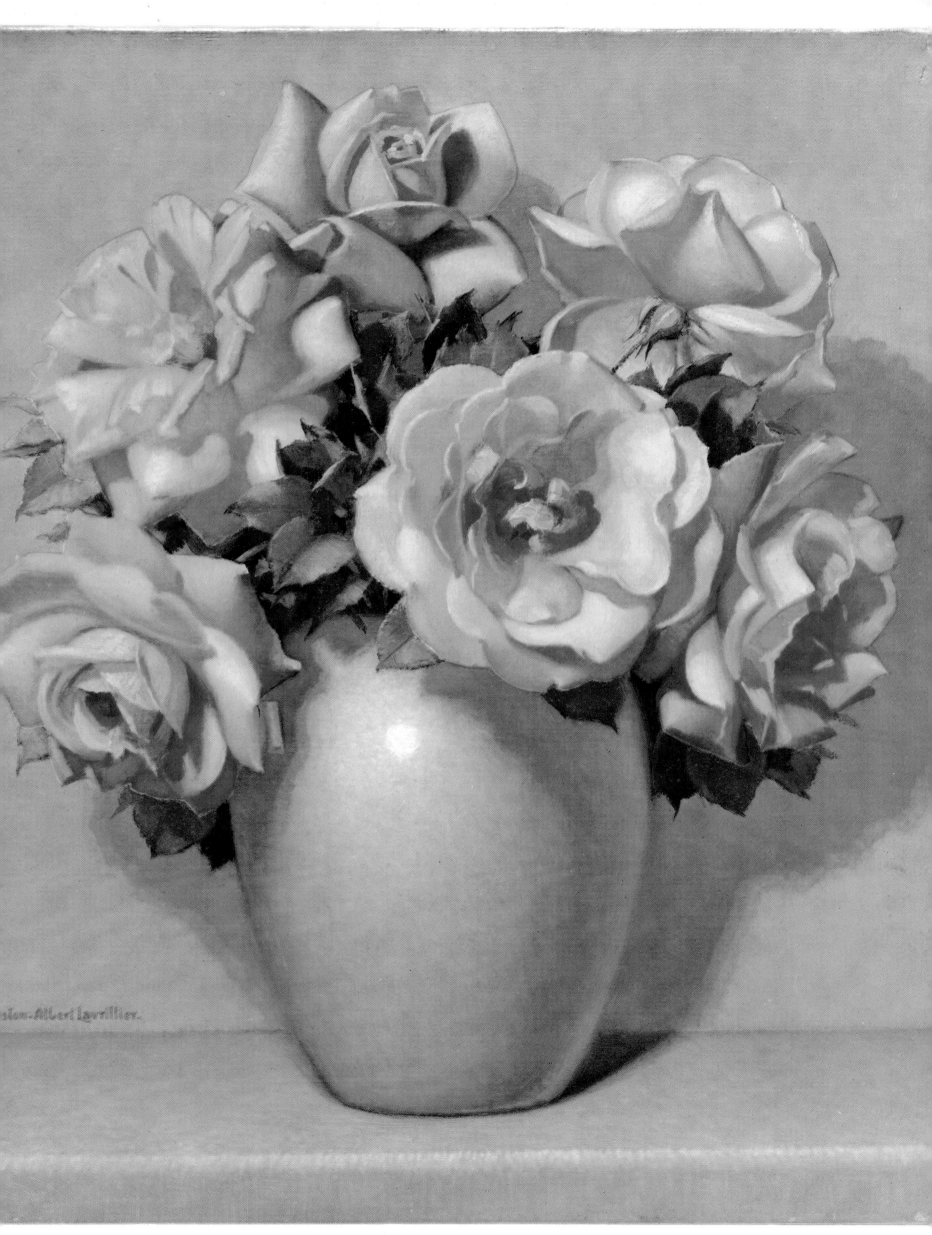

Gaston-Albert Lavrillier.

*W*HEN painting flowers and until you have had quite a bit of experience it is best to carry your step-drawings in pencil or charcoal, much farther than the first step here. I show different stages—so choose the one that suits you the best. You will find this out by trying. Just looking won't help you a bit. Shall we start?

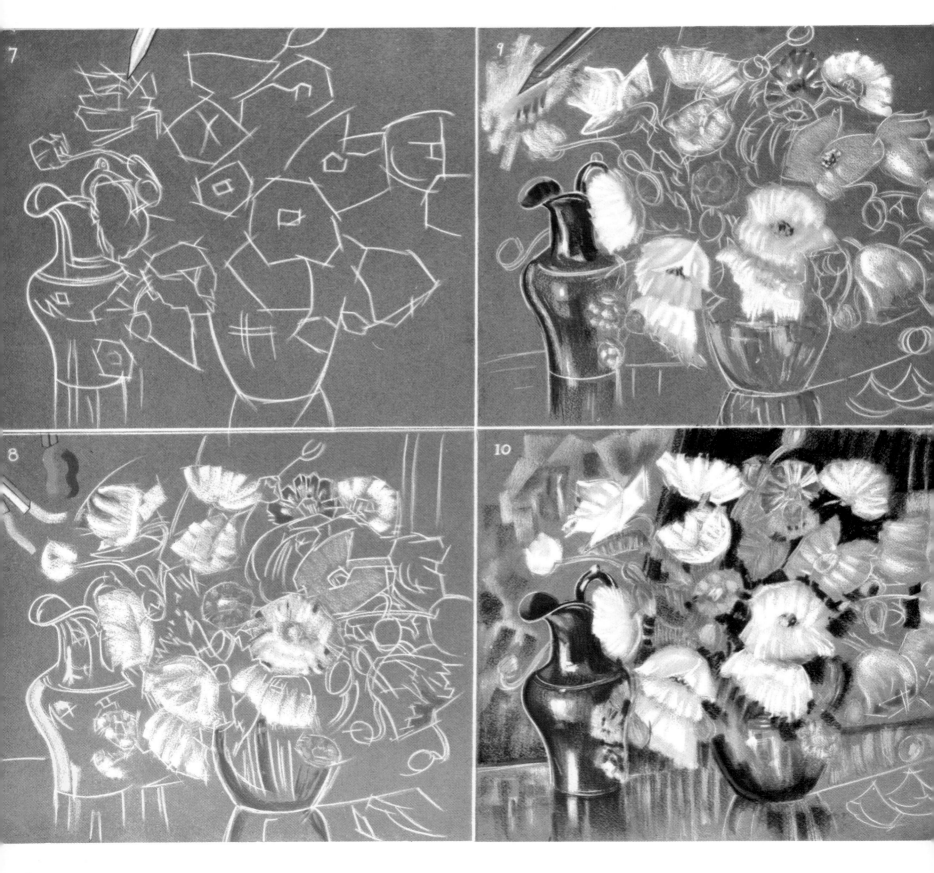

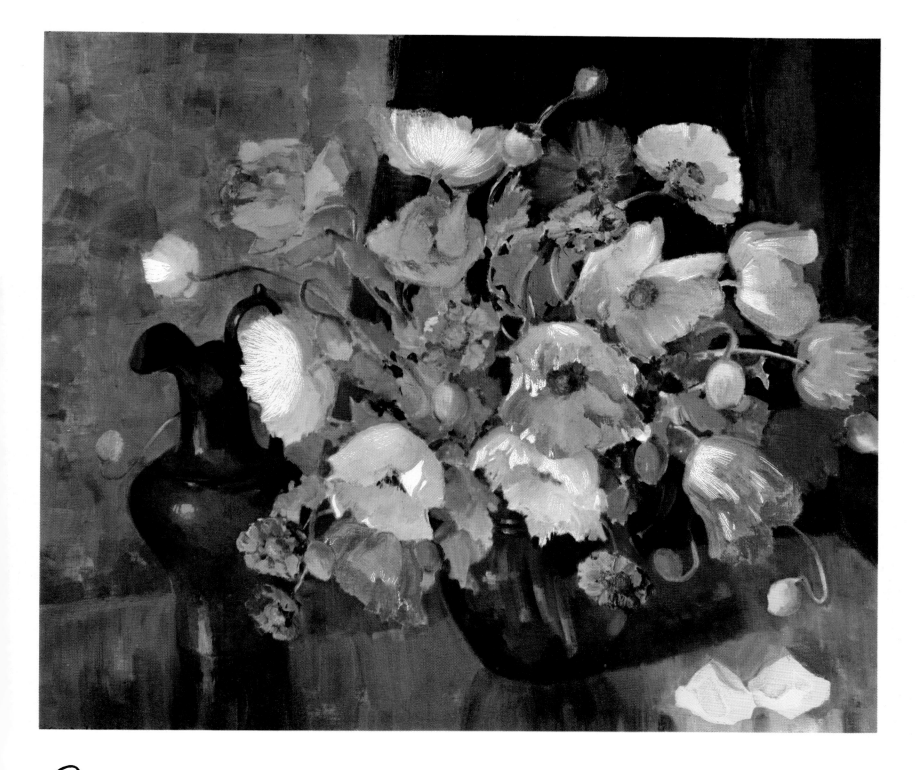

*N*ell Walker Warner is one of our most distinguished artists and has been very successful with her still life painting of flowers. She has now branched out and is finding a ready market for her mountain and East and West coast scenes. The painting above is in oils and is 26 x 30" in size, in a 32 x 37" frame. Nell made this for our dining room. It has been a great joy to us and our friends and when it came back, (after a six weeks absence having color plates made), we felt that our child had returned. You can use this study also for oils and water colors. Make same size or larger but not larger than 18 x 20". Pastels are easy to work with and you will experience very little fading in the colors, but will dust off if not protected with fixatif and glass. See pages 2, 4 and 5, for materials and directions.

With the best of success to you and happy drawing.

This page was made with Oil Pastels. It has its advantages and disadvantages, it does not dust or rub off, but then at the same time it does not blend as easily. You can work regular pastels with it and they become Oil Pastels. You can work over a water color as shown in small drawing or you can work the Oil Pastels on canvas and use turpentine and brushes to blend. So, if interested try it out.

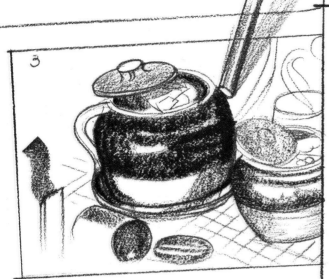

3

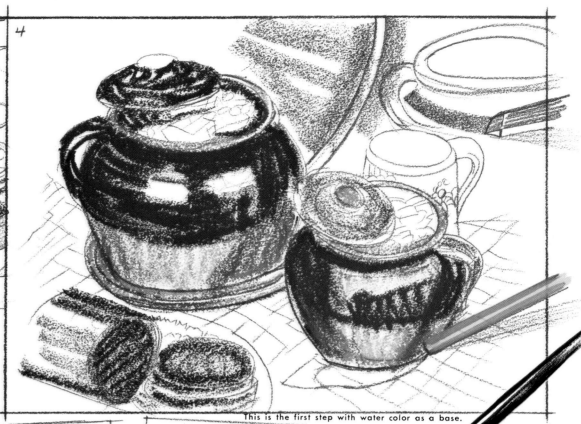

4

Step 3
Now you have your outline drawing you can start shading, use broad strokes and keep simple. The larger drawing to the right will give you more of the coloring as well as a more detailed drawing. Oil Pastels, applies and feels a lot like cold cream, you can use the regular pastels with it.

This is the first step with water color as a base.

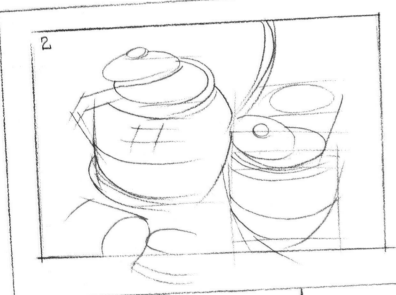

2

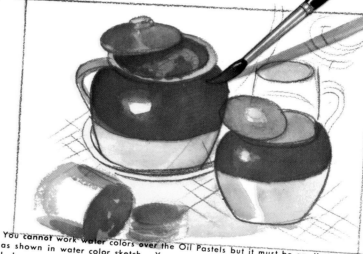

You cannot work water colors over the Oil Pastels but it must be applied first as shown in water color sketch. You can go farther with water colors than I show or you can scrape out the pastel with razor blade or knife and use casein for highlights or to correct your work. Experiment for yourself, which is always a good way to learn.

Step 2
We have decided on size, next is perspective. All objects should be in the same perspective (the so-called modern painters ignore correct perspective—that is old fashioned to them), but what do you say we stick to the same perspective.

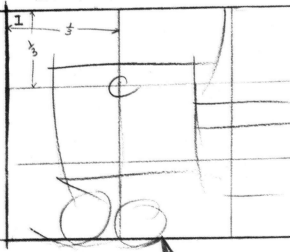

1

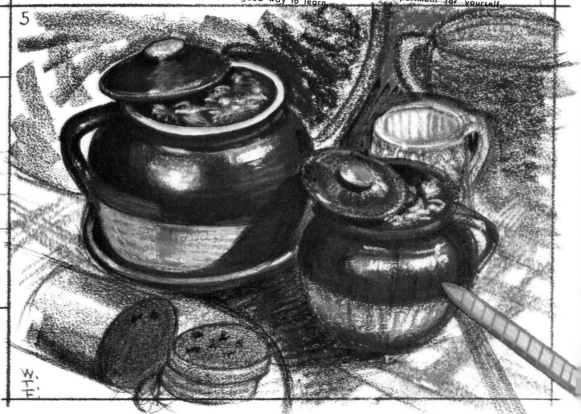

5

W.T.F.

Step 1
You can divide the space in thirds and place your most important objects on or around the third as shown with C, or you can use either one of the three cross lines for your most important object in your composition. Placement and size of objects are important at this stage of your painting. See other layouts on pages 15 and 18.

20

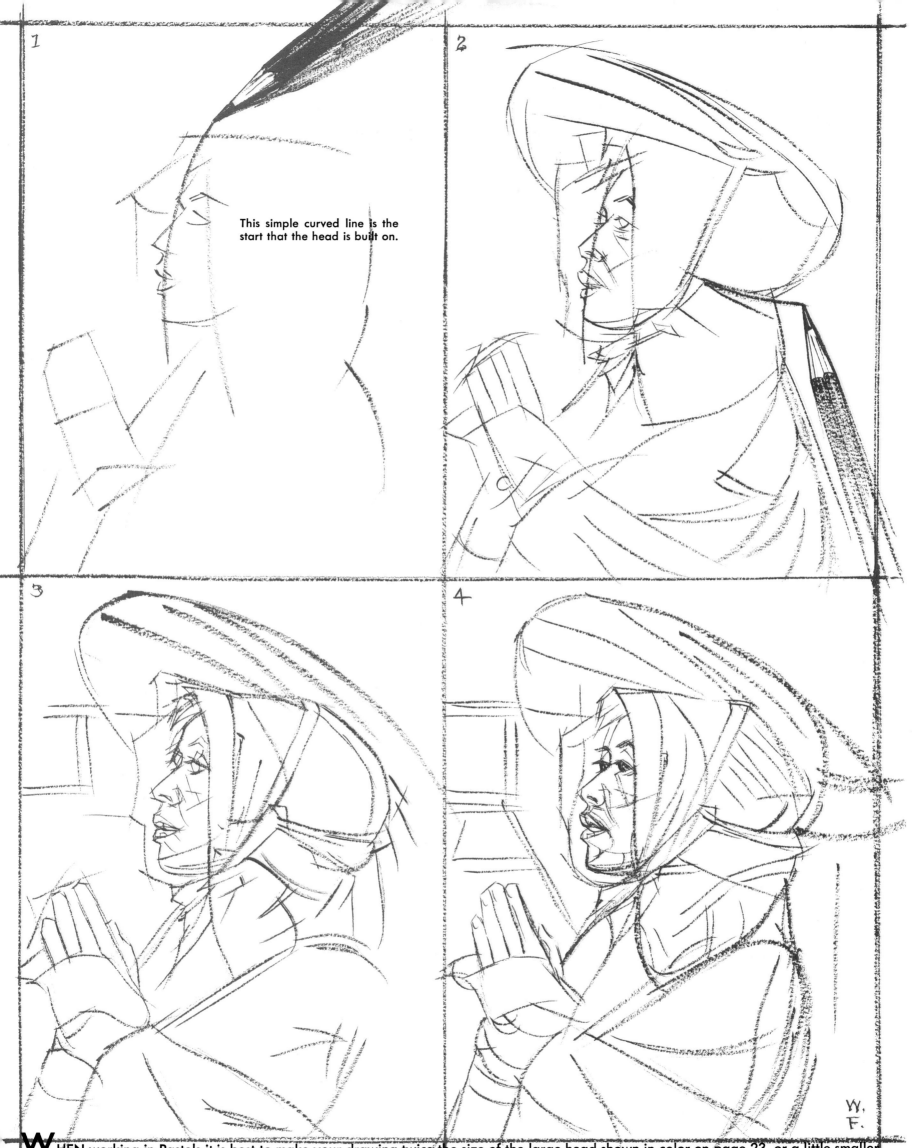

1

2

3

4

This simple curved line is the start that the head is built on.

W, F.

WHEN working in Pastels it is best to make your drawing twice the size of the large head shown in color on page 23, or a little smaller than life size because of the size of the pastels although if you wish to do this and other subjects in colored pencil or small crayon this size is all right. Think as you work and it is a good idea to think before you start too. Working from an oil painting such as this one on page 23 of Linford Donovan makes you think for yourself which is wonderful practice. Get pleasure out of your practice—it isn't a life or death deal. Sure. Have fun.

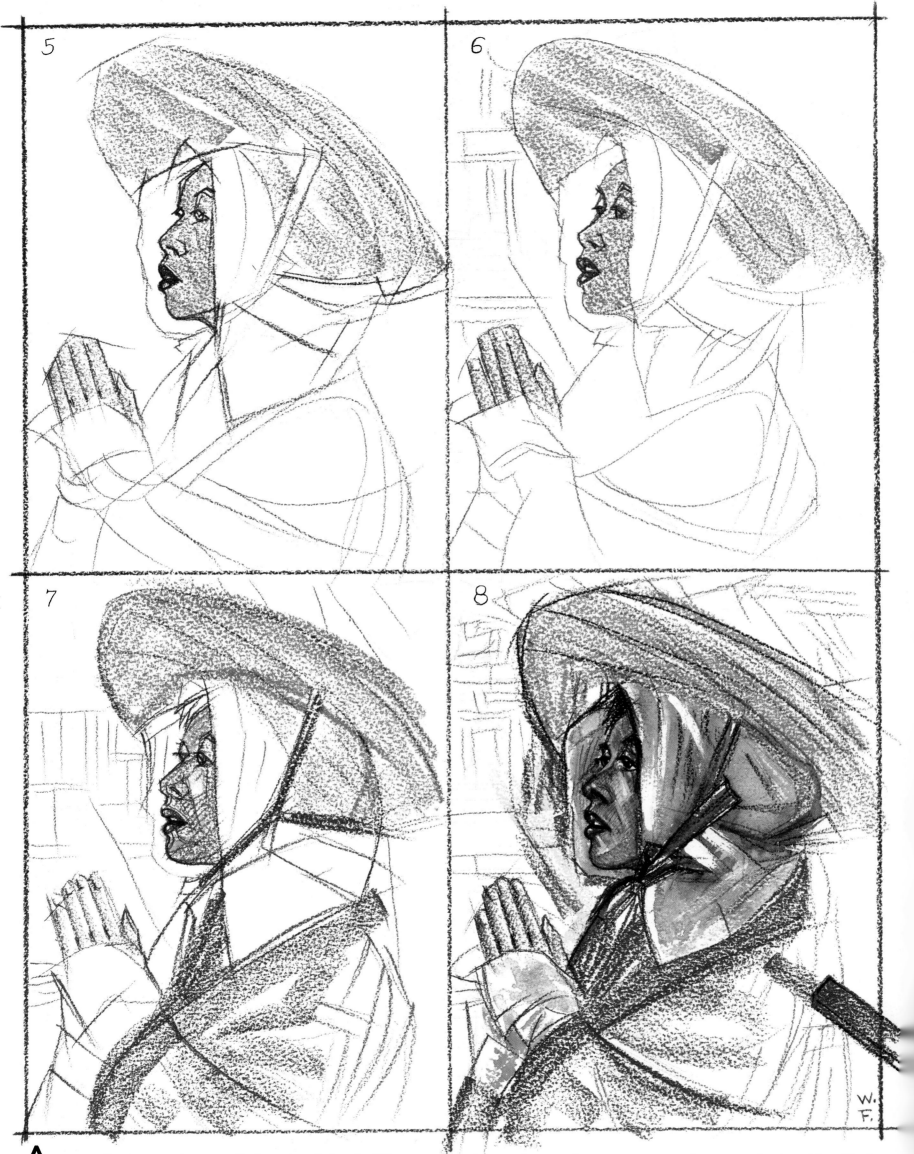

AS you will notice each step will change a little. A different expression on the mouth, nose, eyes or a longer or shorter chin will also do it. What should you do about it? Erase and try again.

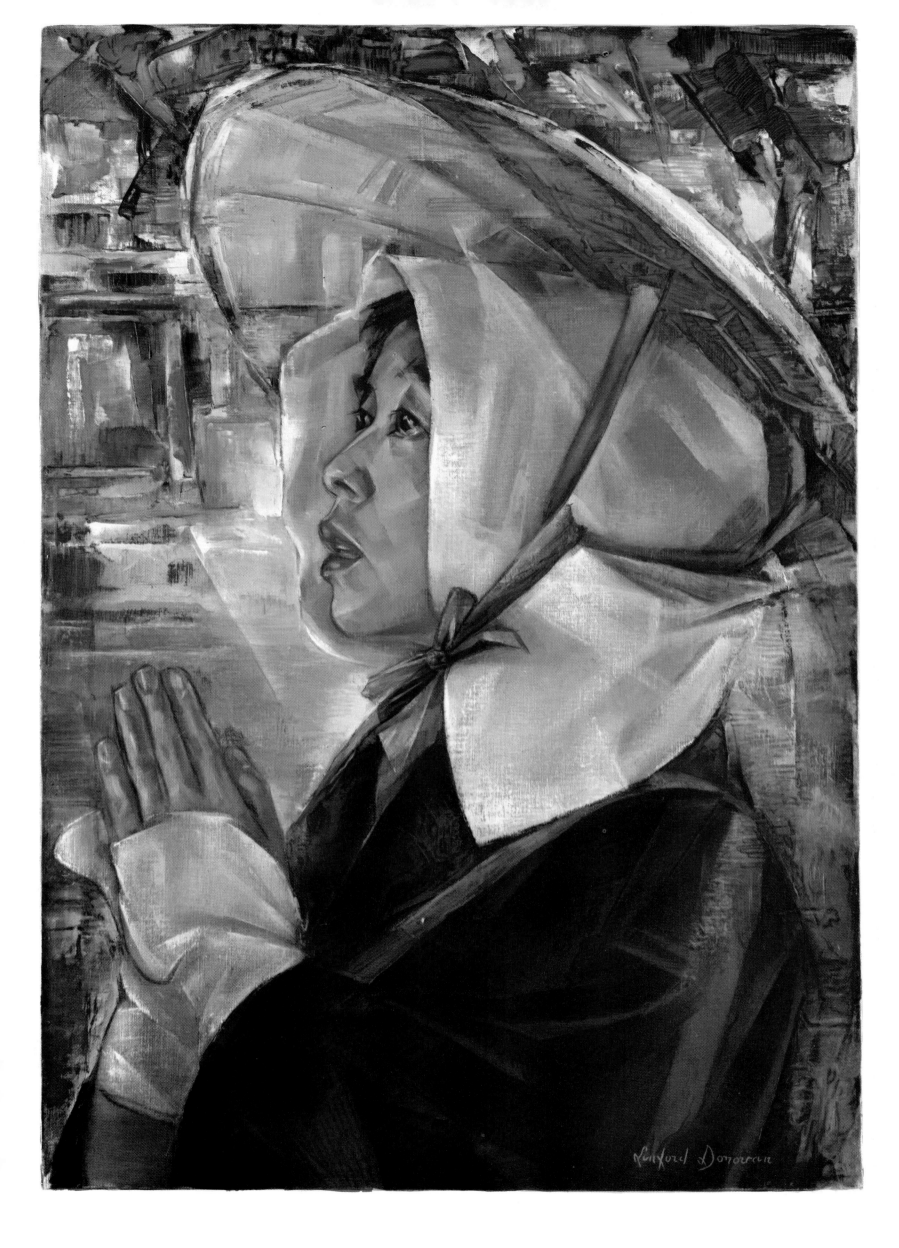

Your blocking-in and step-drawings are the same, whether you are working in oils, water-color, casein or pastel. So many think there must be some trick or hocus-pocus to working in each medium. It is all just good old-fashioned trying and learning from your blunders. No try, No Learn! Just as simple as that.

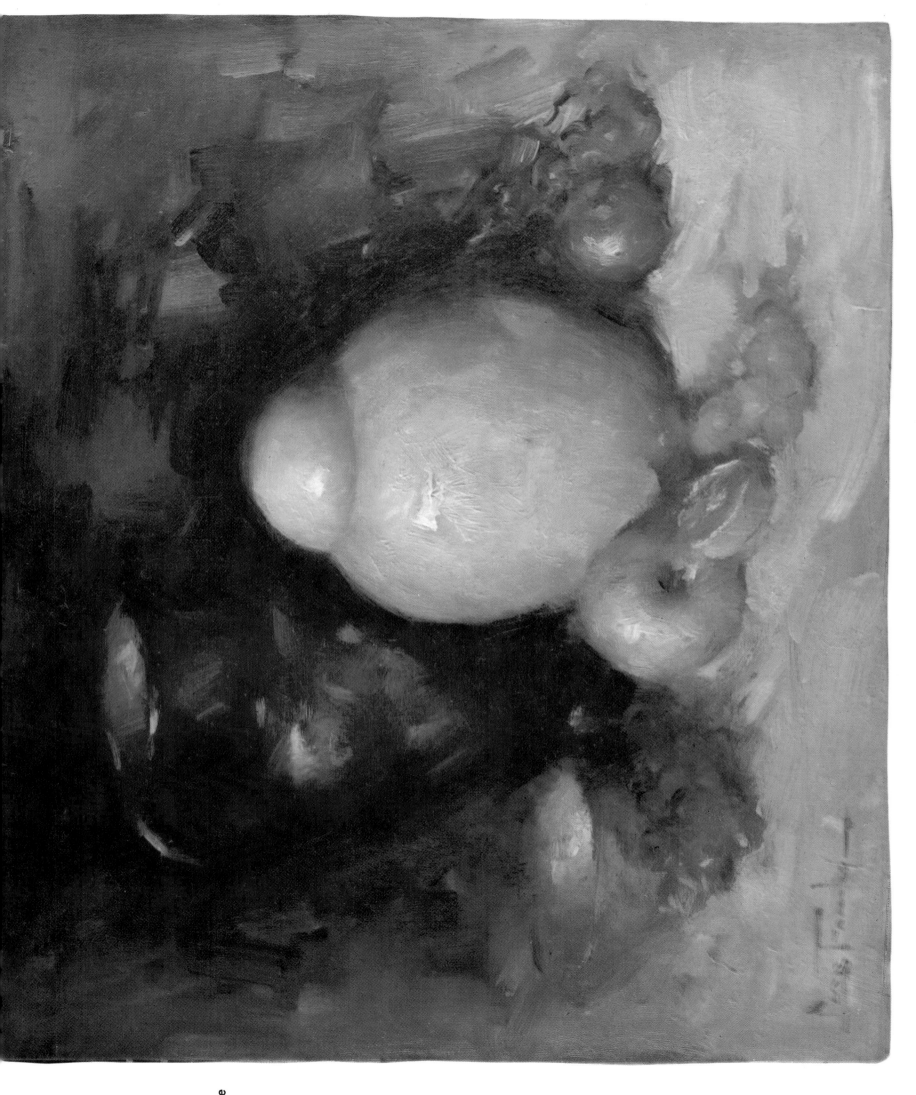

Leon Frank made this painting for his "Still Life" book and not having room I have decided to use it as an ideal subject for pastels, although it was painted in oils. Never feel that because a study is in oil, watercolors or black and white that you cannot work from it in pastels or any other medium. This is the best practice you can have as you must think what you are doing while you work.

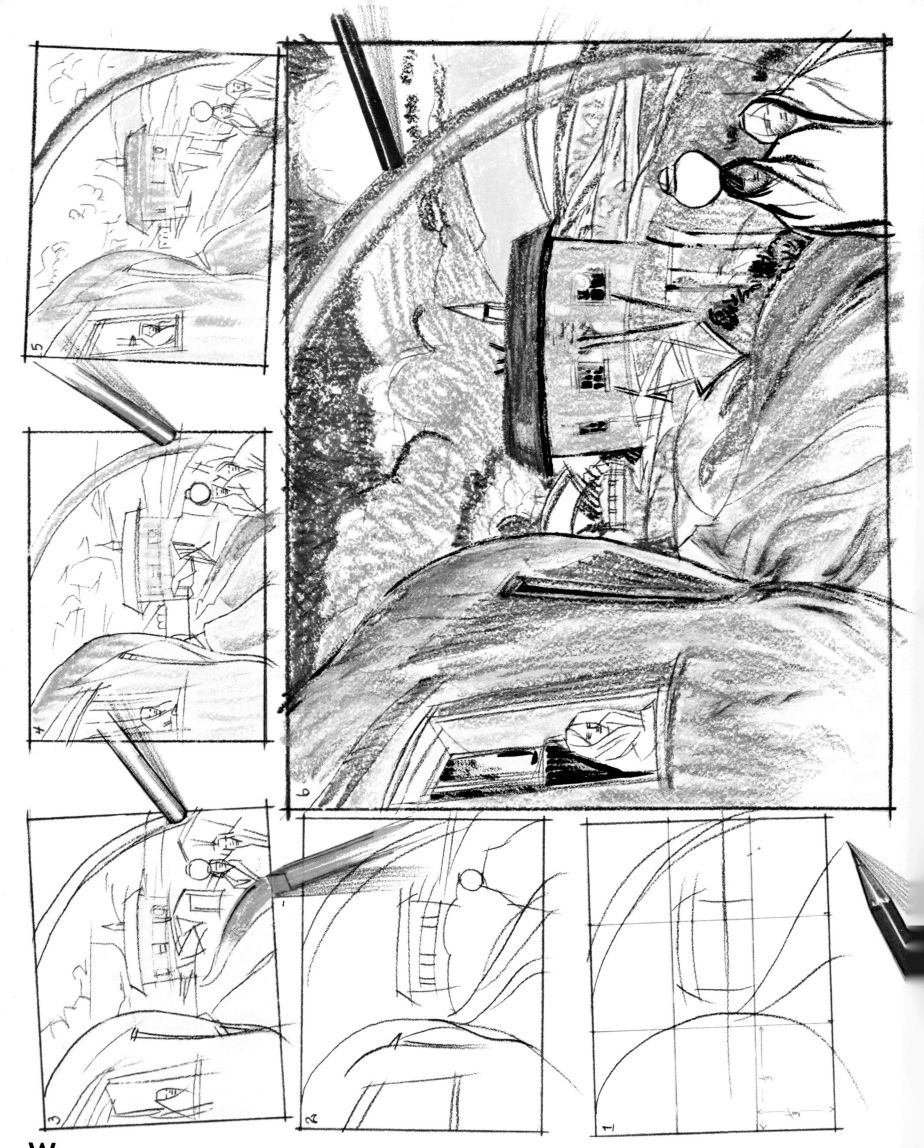

Walter Ufer was more than a great painter. He was a great thinker, and an artist without thinking and the ability to draw and apply his materials, whether oil, pastels or water color, ends up like so many paintings, square fruit, round boxes, pasting patches on canvas and then calls it Modern Art. I have no quarrel with a good modern but I dislike seeing people taken in by poor work. This is an Oil but I want you to work it in Pastel. Of course, try it in Oils or Water Colors too, you cannot find more helpful practice. All success.

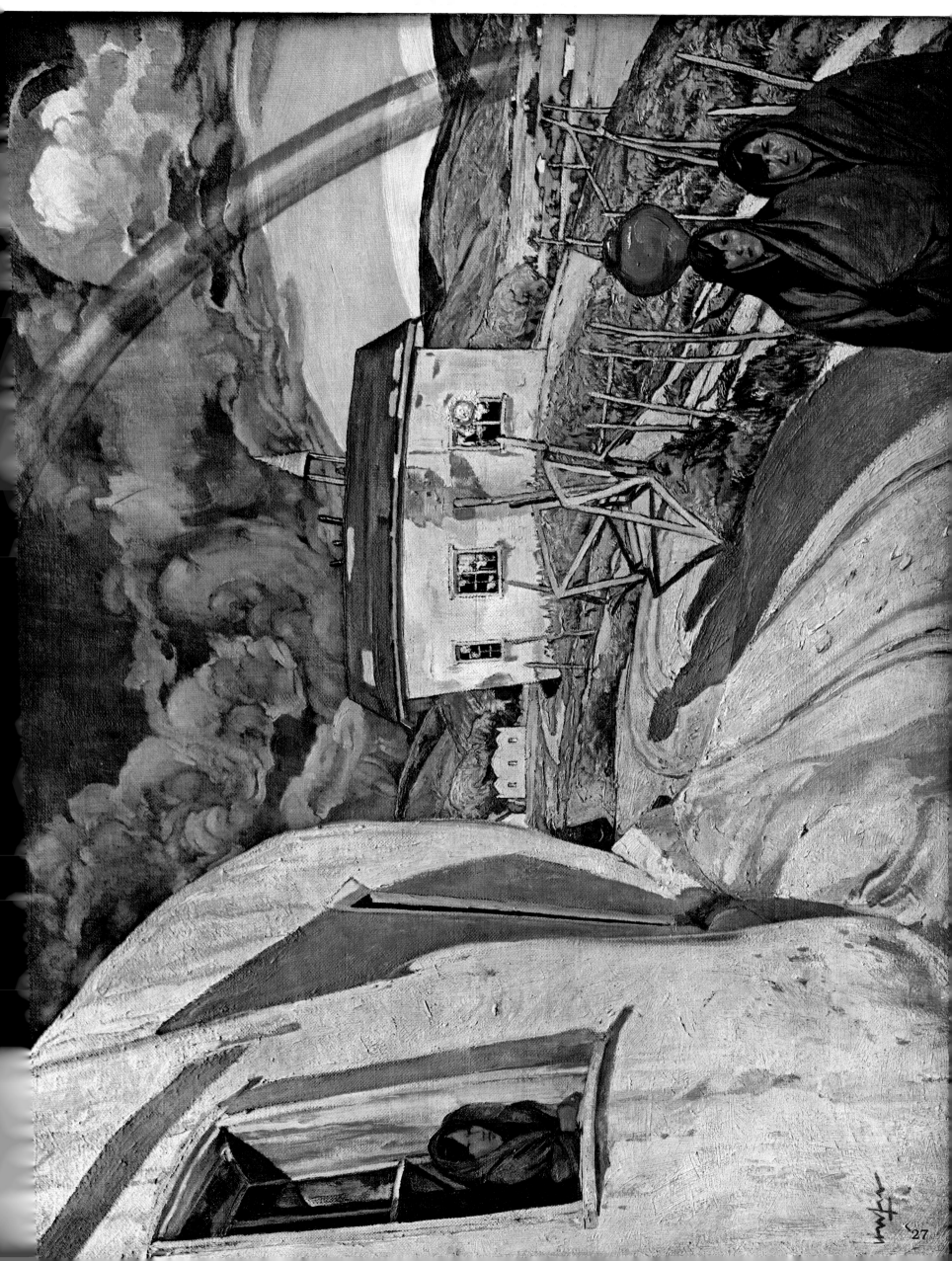

1

Think of your most important object along with your composition as a whole. Make a simple blocking-in. This is just a shorthand note of where you want each shape to go (boat in this case).

Now that you have placed each boat in its proper place you can now pull it together by drawing their true form. When this has been done you are then ready to apply the colors.

3

After you have the larger masses of color on your drawing, start to refine and make it like the large picture. The size of the original is 18" x 20".

AS I look at this picture I can recall many such scenes in Hong Kong Harbor, Singapore and other parts of the world, each person on his little mission of delivering fruit, fish, coal and other merchandise, and it is a way of life that they choose, or most likely forced into through necessity. These boatmen are mostly women with babies tied on their backs along with two to four playing in the boat. We are very fortunate if engaged in work that allows us to follow the dictates of others and bend to their will. Free time is precious—use it well.

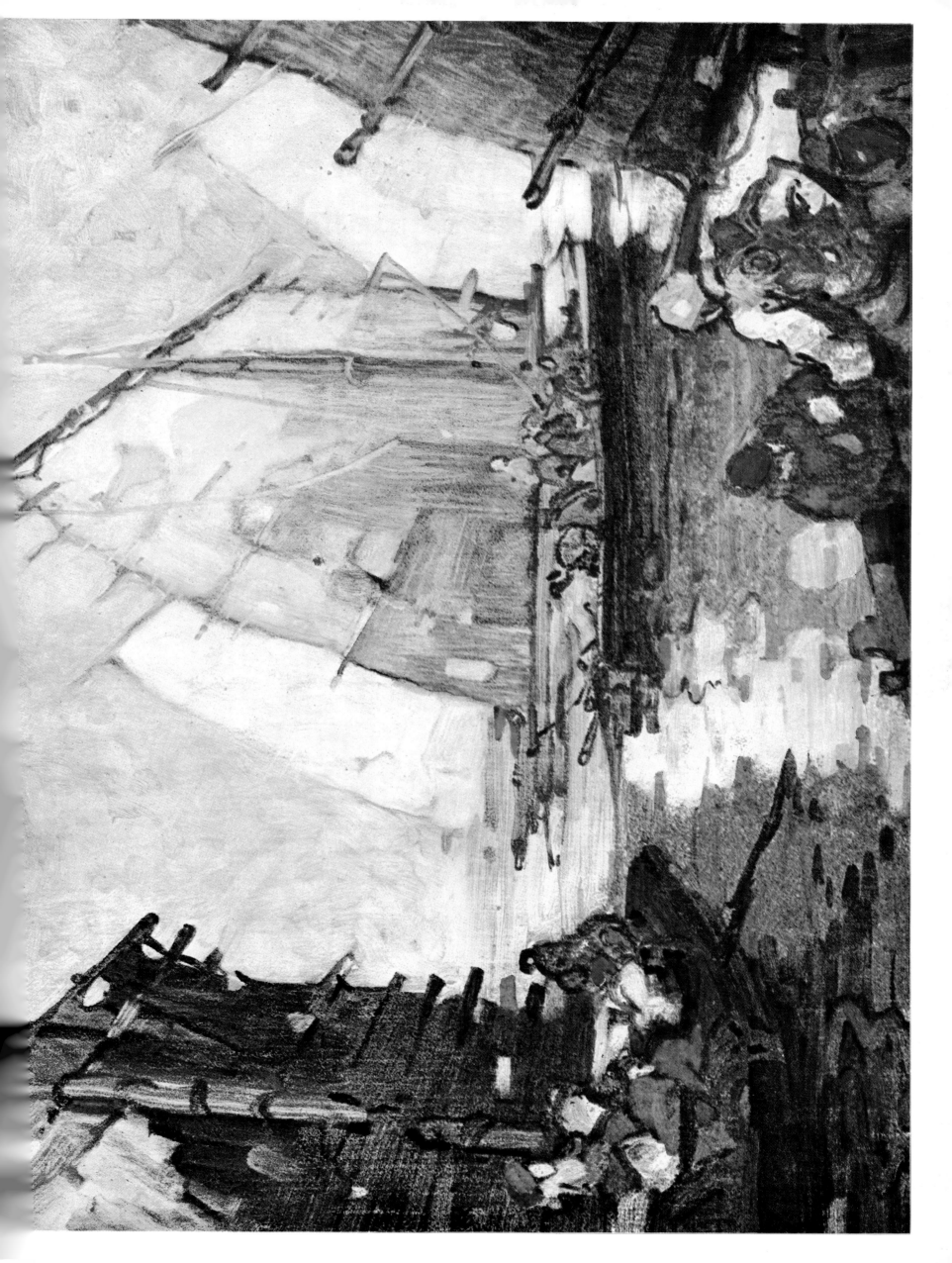

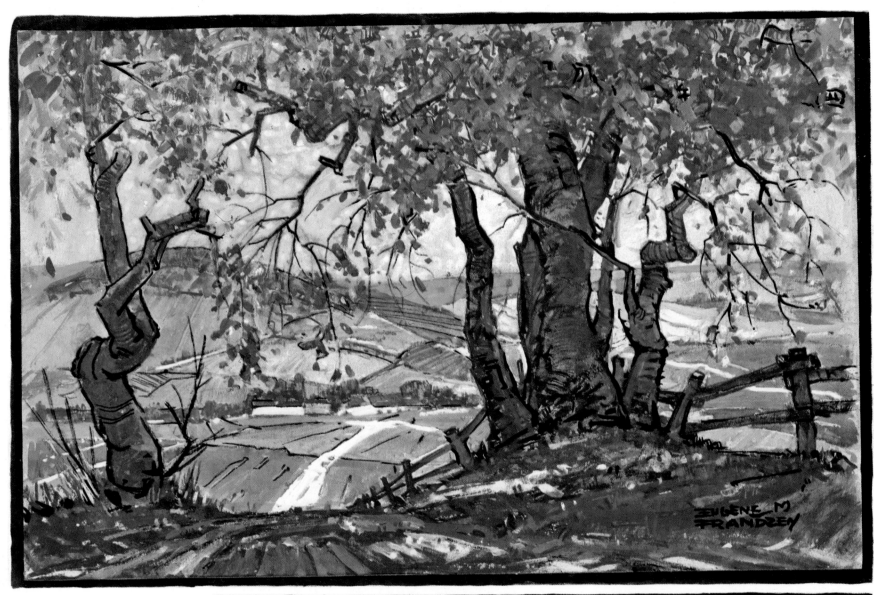

Pastel is a medium that can be used many ways. On this page are two color paintings that are done principally with casein colors. The casein light tones have color and white mixed. The darker tones are pure casein and water. Some india ink is brushed on throughout the top, painting in the outlines and shading.

Over these casein tones high-keyed semi-hard pastels were used to speed up some of the color areas in both paintings. The pastel tones were applied crisply and directly. They were left that way without any rubbing. Even in the distant parts of both landscapes, cool purplish and bluish tones of pastels have been used. The originals of these paintings are small, only one third larger than you see them now.

Pastels alone (without the casein underpaintings) could be used to make the entire picture on the right. Note the mosaic-like areas all over the job that could be filled in with simple flat pastel tones and left crisp and sharp with no rubbing.

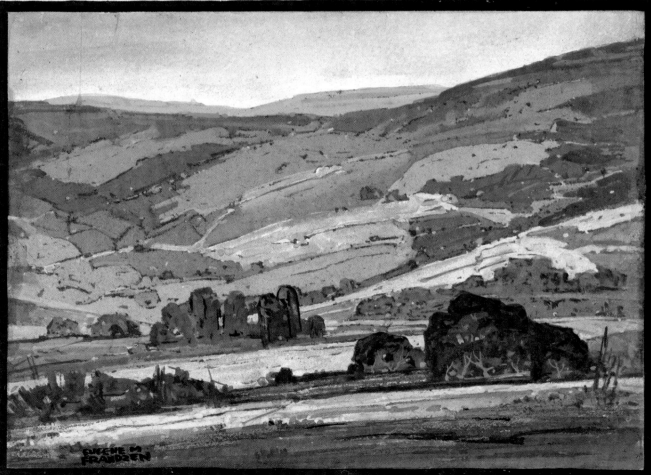

Eugene Frandzen is one of our outstanding painters, both in Oils, Casein, Water Colors and Pastels, and we are very fortunate to be able to show his fine work and wish you could see the sparkle in the originals.

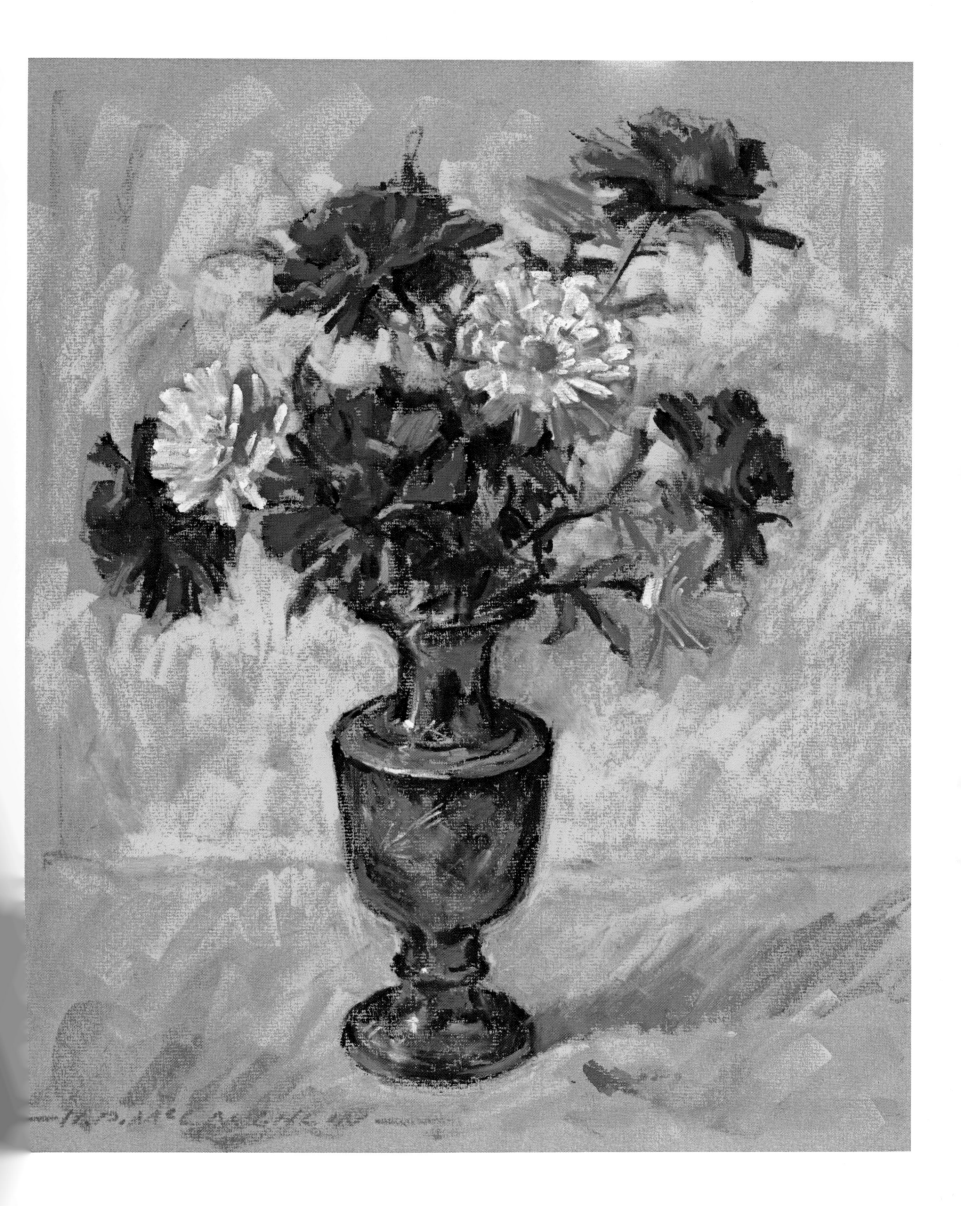

More Ways To Learn With

Beginners Art Series

The **Beginners Art Series** is a great way to introduce children to the wonderful world of art. Designed for ages 6 and up, this popular series helps children develop strong tactile and visual skills while they have a lot of fun! Each book explores a different medium and features exciting projects with simple step-by-step instructions and illustrations.

Paperback, 64 pages, 8-3/8" x 10-7/8"

Artist's Library Series

Serious instruction for serious artists—that's what the **Artist's Library Series** is all about! The books in this series can help both beginning and advanced artists expand their creativity, conquer technical obstacles, and investigate new media. Each book explores the materials and methods of a specific medium and includes step-by-step demonstrations, helpful tips, and comprehensive instructions.

Paperback, 64 pages, 6-1/2" x 9-1/2"

How To Series

No matter what the medium or the subject matter, we have a book in our **How To Series** to fit every artist's needs.

Filled with step-by-step illustrations of techniques for various media, these books address the full art spectrum—pen and ink, pencil, pastel, charcoal, watercolor, acrylic, and oil—and all skill levels.

Paperback, 32 pages, 10-1/4" x 13-3/4"

Blitz Cartoon Series

The **Blitz Cartoon Series** is designed for people who just can't stop doodling!

Bruce Blitz, creator and host of the Emmy-nominated Public Television series, "Blitz On Cartooning," believes that anyone with desire and a positive attitude can learn to draw—so he has developed these books demonstrating fun and easy methods for turning "doodles" into finished drawings, cartoons, and comic strips.

Paperback, 48 pages, 10-1/4" x 13-3/4"

Collector's Series

Each book in the **Collector's Series** contains a selection of some of the most popular books from our "How To" Series—all combined in a high quality, hardcover edition.

Compiled from many of our bestsellers, each of these books begins with the fundamentals of the particular medium and then explores the techniques, styles, and subjects of the various artists.

Hardcover, 144 pages, 10-1/4" x 13-3/4"

Disney Learn To Draw Series

The Walt Disney Company and Walter Foster combined their talents to create this wonderful series of art books for children.

Each book in the **Disney Learn To Draw Series** features a different set of characters and includes step-by-step instructions and illustrations, tips on outlining and coloring, and hints on how to create different poses and expressions.

Paperback, 32 pages, 10-1/4" x 13-3/4"

Disney Classic Character Series

Everyone will enjoy learning to draw the characters from Disney's classic animated films *Bambi, The Little Mermaid, Aladdin*, Beauty and the Beast** and *Snow White**. The books in the **Disney Classic Character Series** contain easy-to-follow instructions and tips from Disney artists as well as interesting facts on the making of the film.

Paperback, 48 pages, 10-1/4" x 13-3/4"

Drawing Kits

You will love our new **Drawing Kits!** We have taken two of our best-selling drawing books—*Cartoon Drawing* by Bruce Blitz and *Pencil Drawing* by Gene Franks—and packaged them with all the supplies required to complete the projects within.

Cartoon Drawing: *paperback, 48 pages, 6-1/2" x 9-1/2"*
Pencil Drawing: *paperback, 64 pages, 6-1/2" x 9-1/2"*